CHRONICLE BOOKS
SAN FRANCISCO

Simultaneously published in the United Kingdom under the title 642 Things to Colour.

Text copyright © 2010, 2016 by Chronicle Books LLC.

Illustrations copyright © 2016 by Chronicle Books LLC.

All rights reserved. No part of this book may be reproduced in any form without written permission from the publisher.

Text pulled from 642 Things to Draw, originally published by Chronicle Books LLC in 2010.

ISBN: 978-1-4521-5435-0

Manufactured in China

Design by Eloise Leigh

10987654321

Chronicle Books LLC 680 Second Street San Francisco, California 94107

www.chroniclebooks.com

an anchor

a skunk

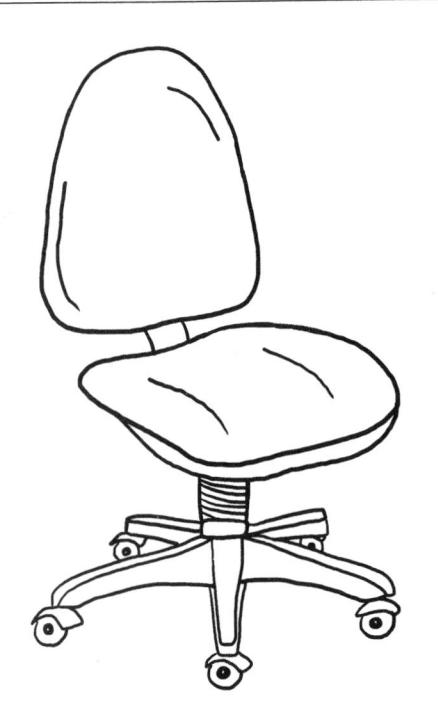

a desk chair

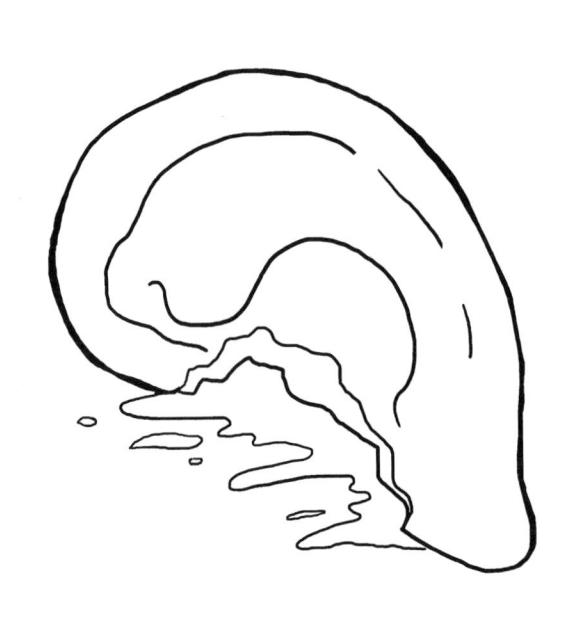

Van Gogh's ear

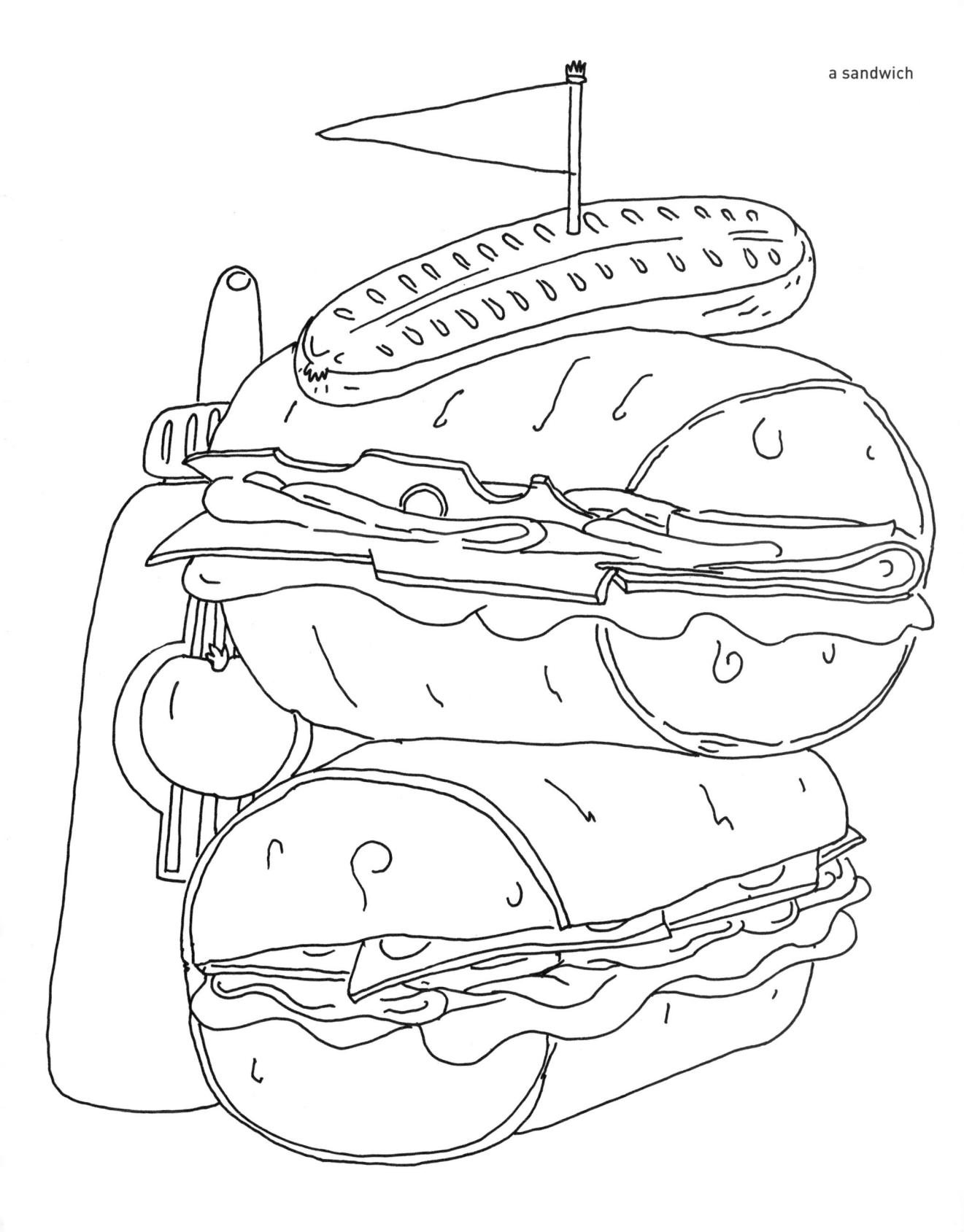

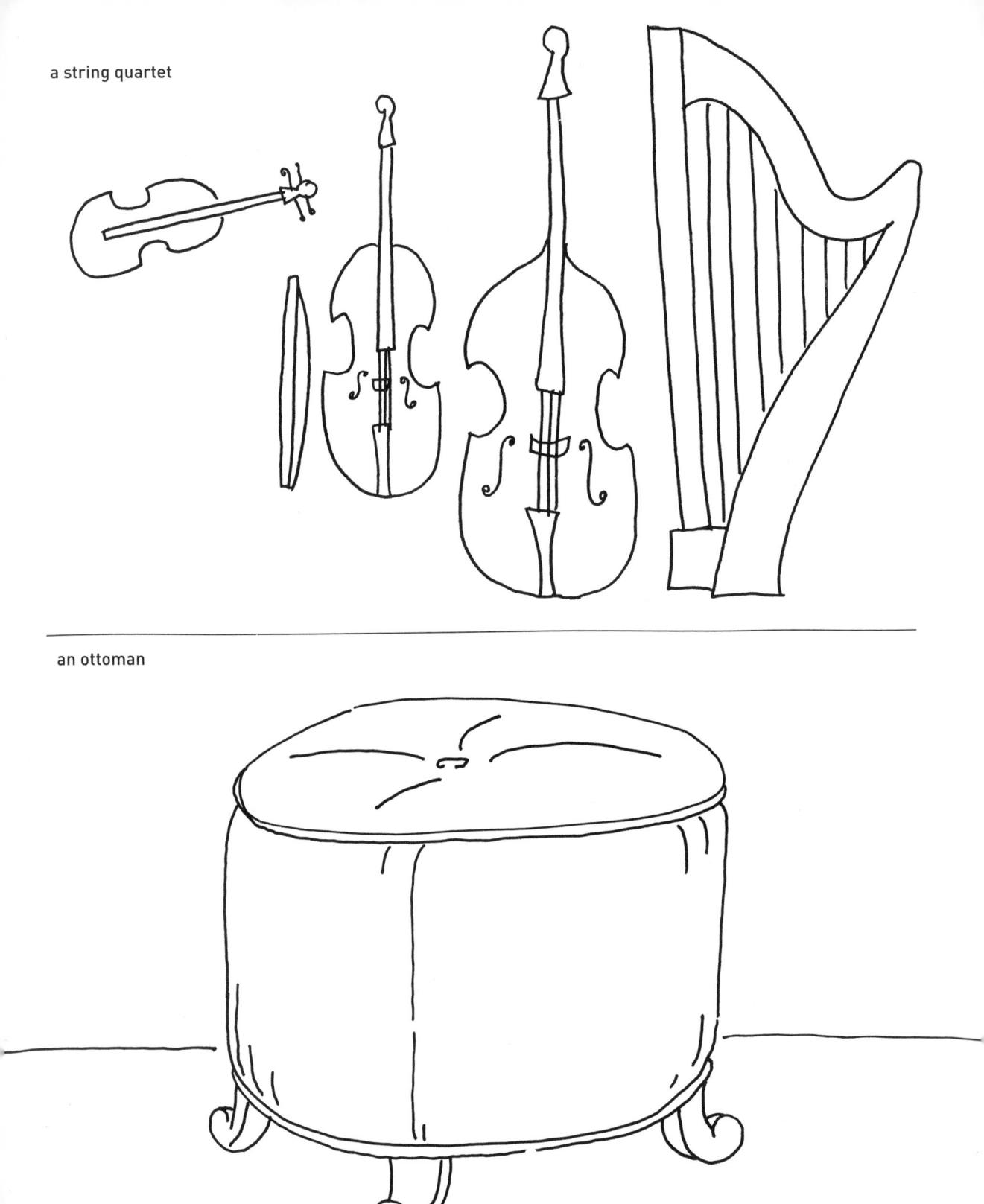

Bob Marley

fangs

a paper clip

a trumpet

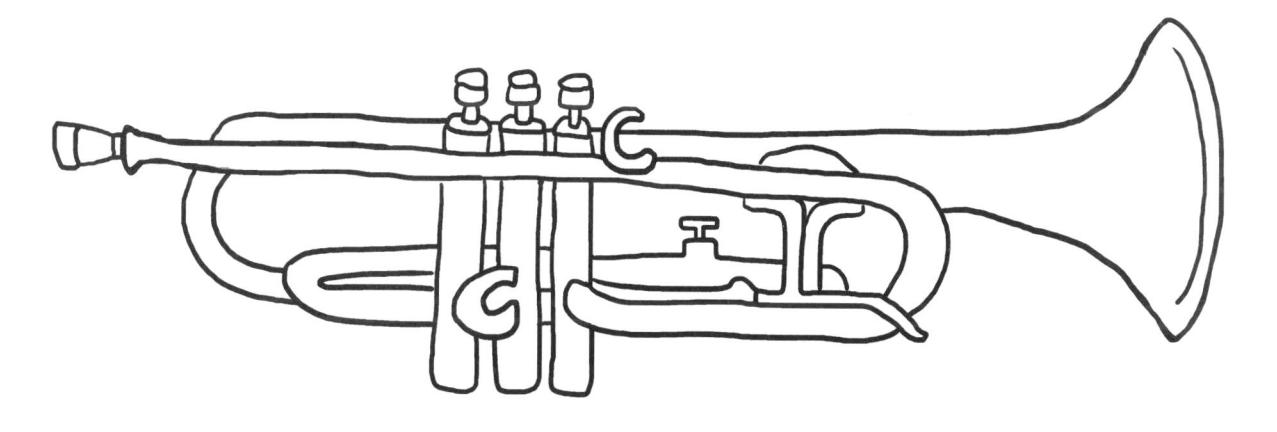

tube socks

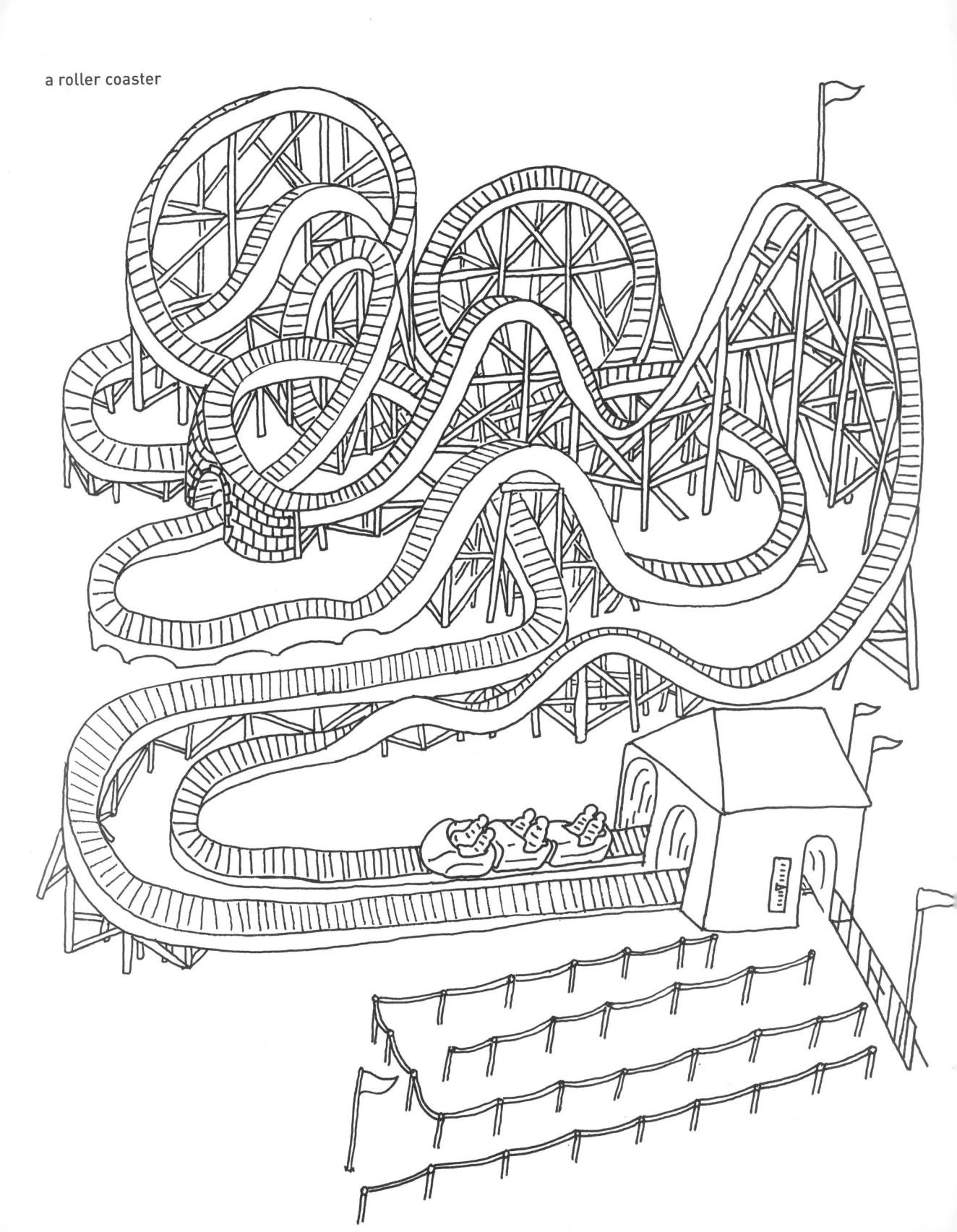

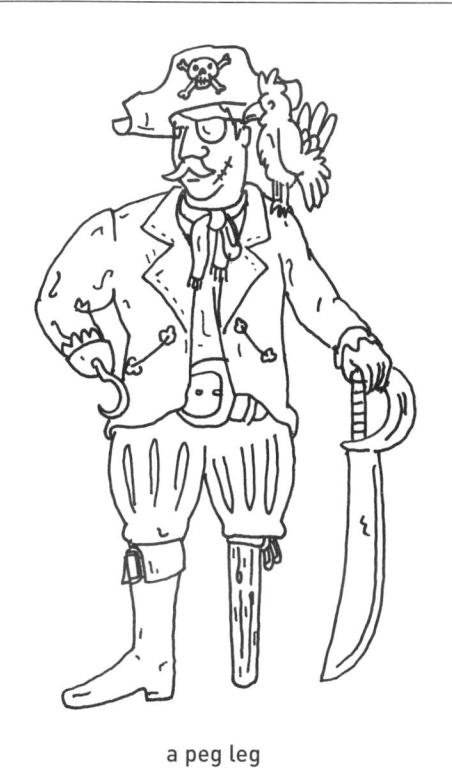

a spigot

an old key

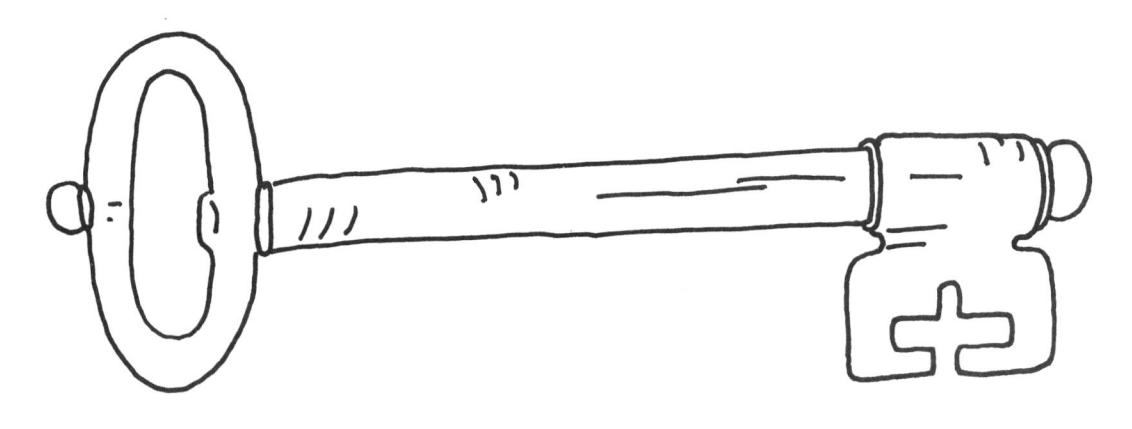

a juice box

a jar full of pennies

a bag of hammers

jelly beans

a paper airplane

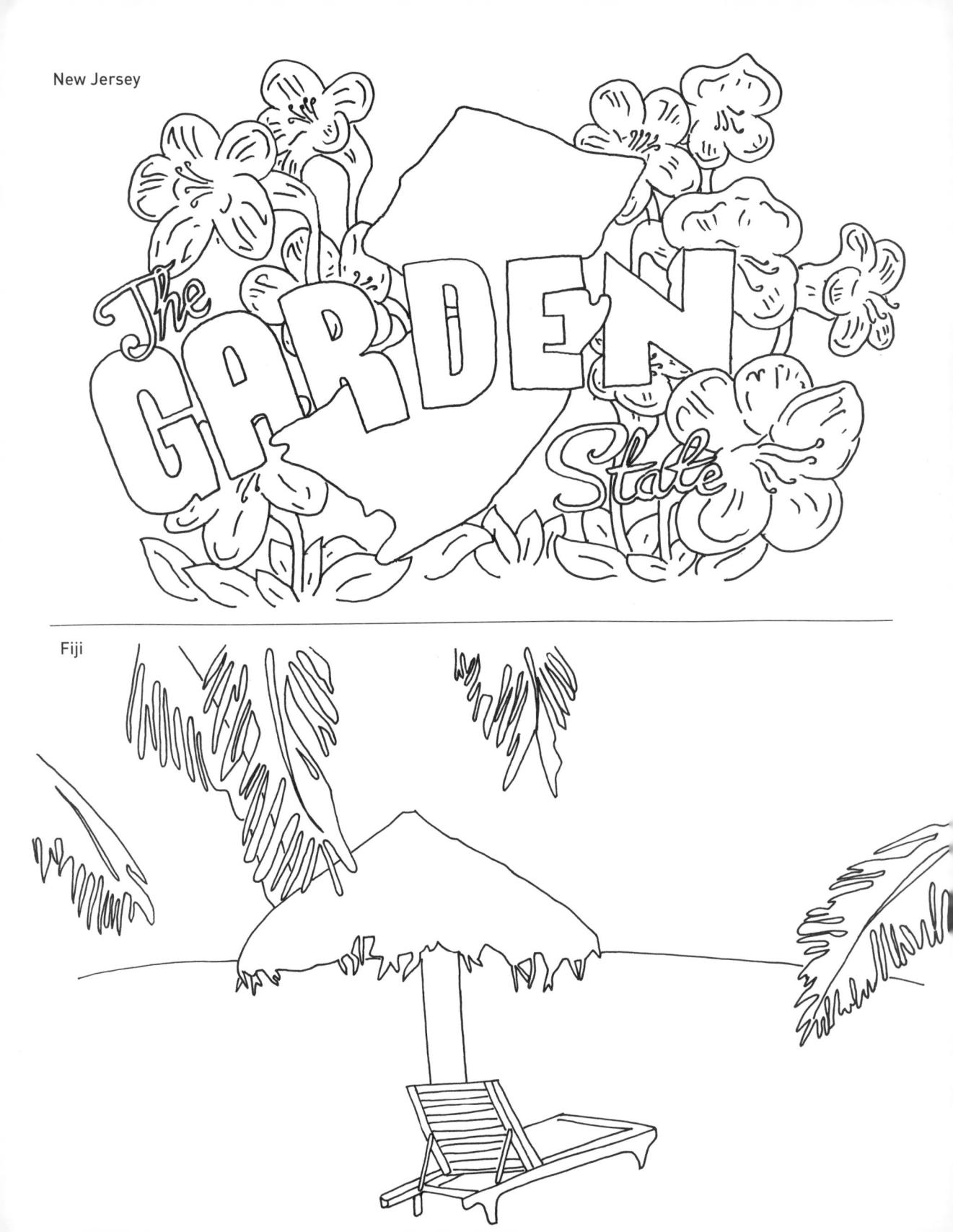

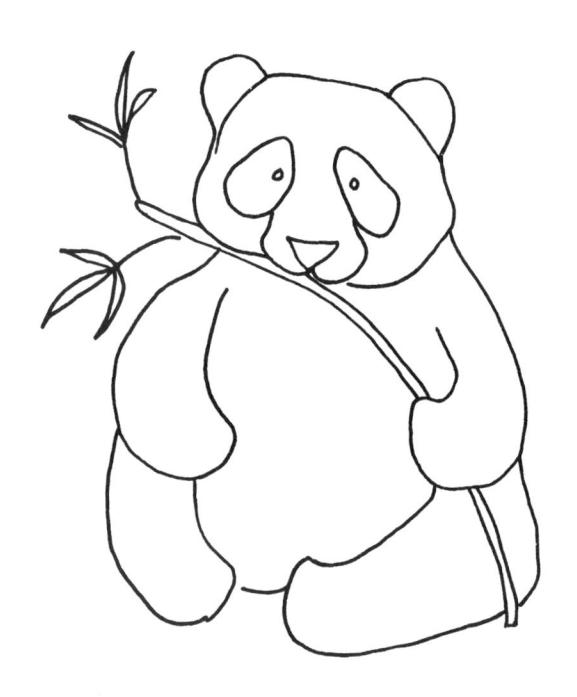

Charlie Chaplin

a penguin

a seagull

a leopard

a ship in a bottle

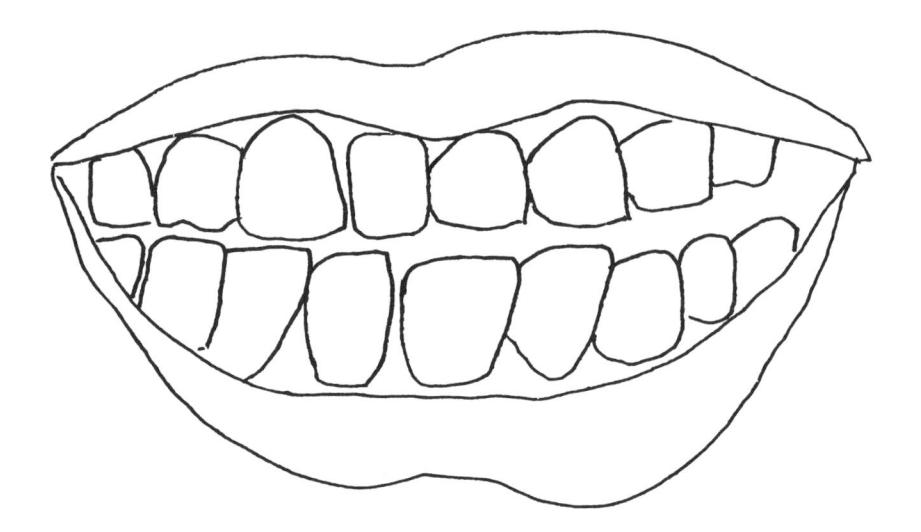

brass knuckles

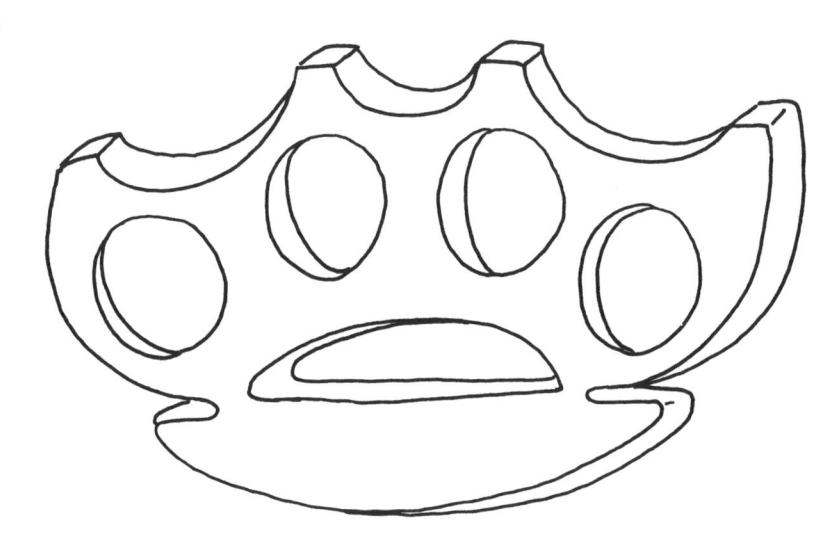

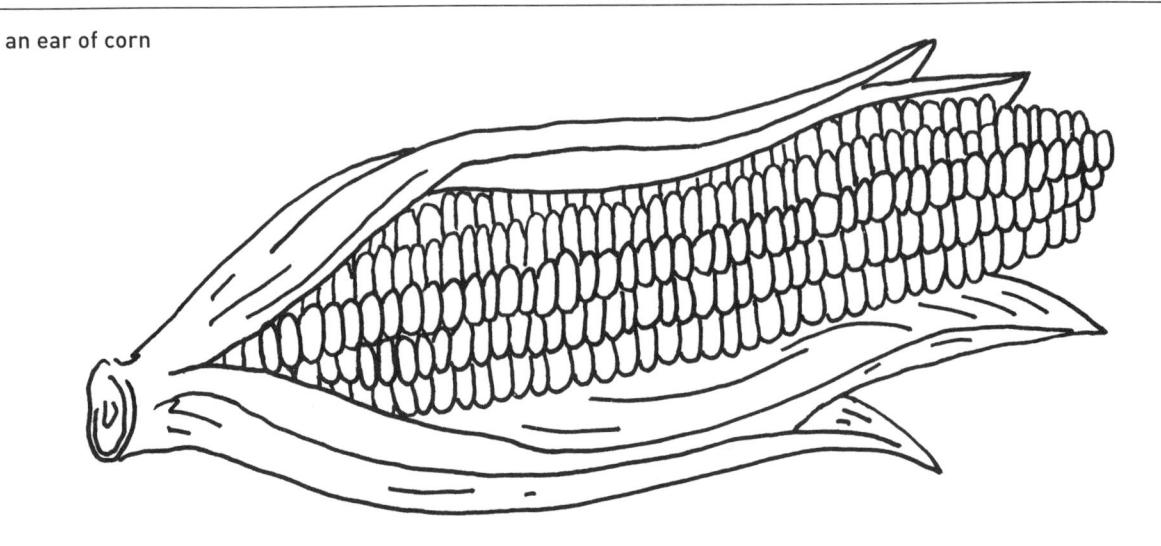
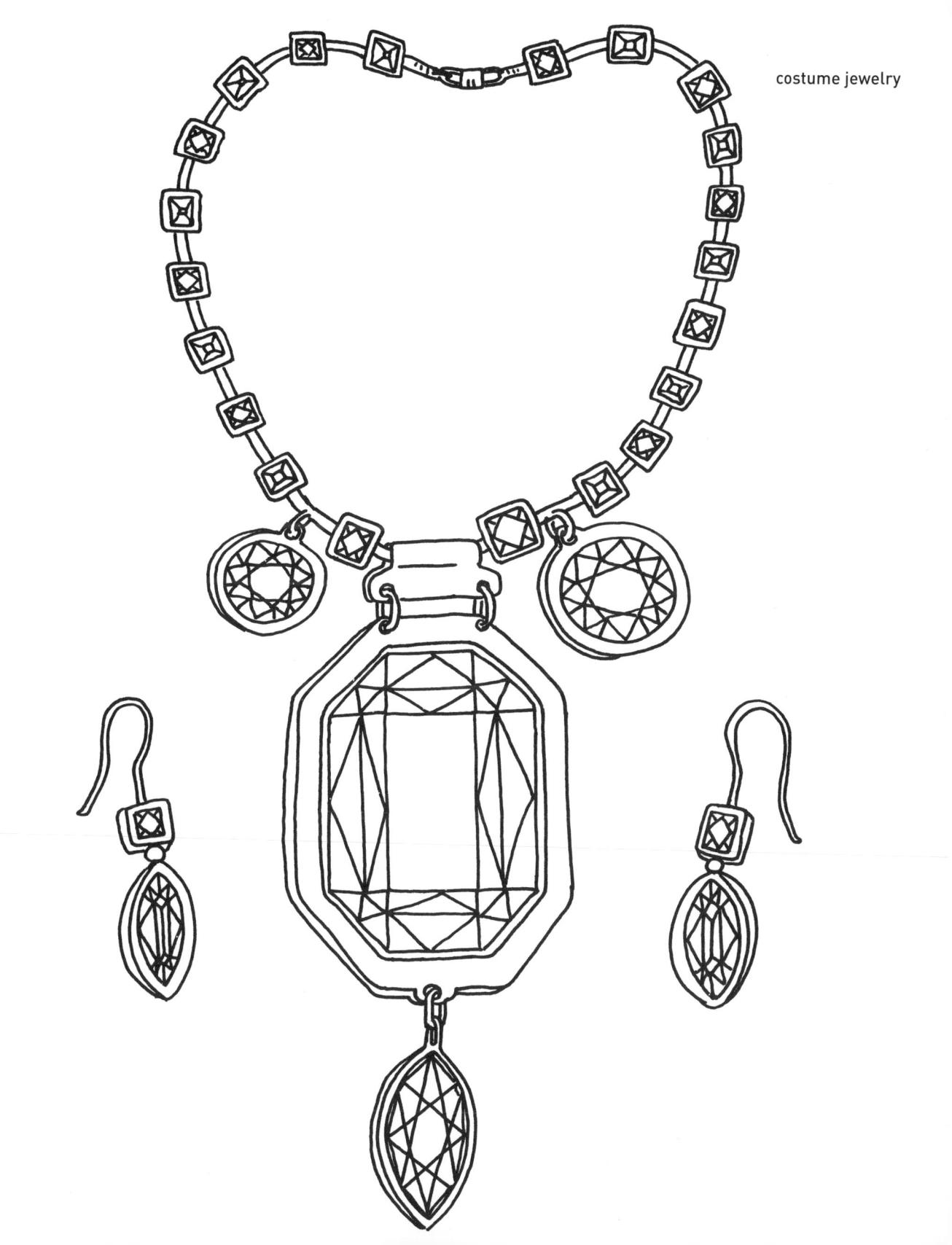

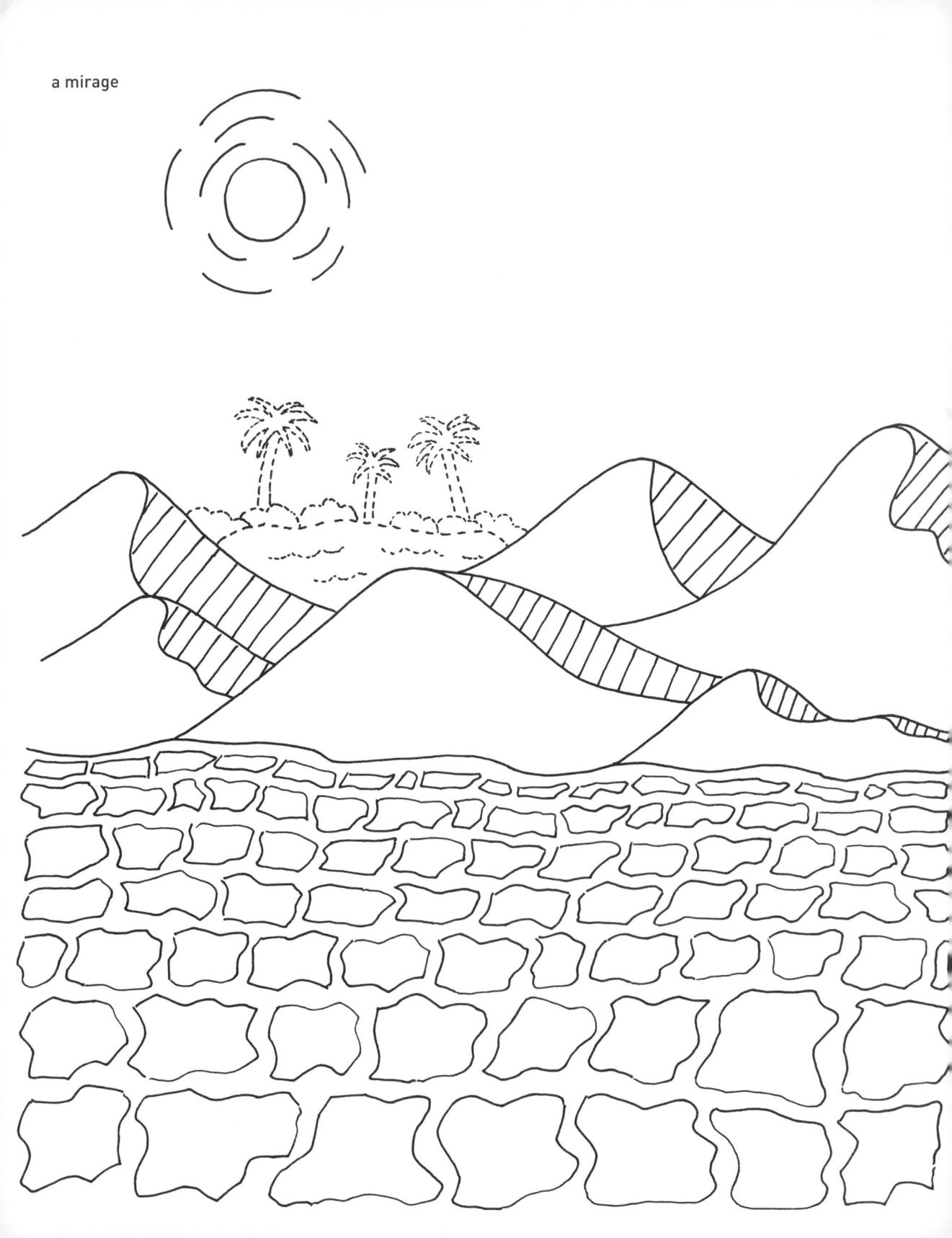

coins

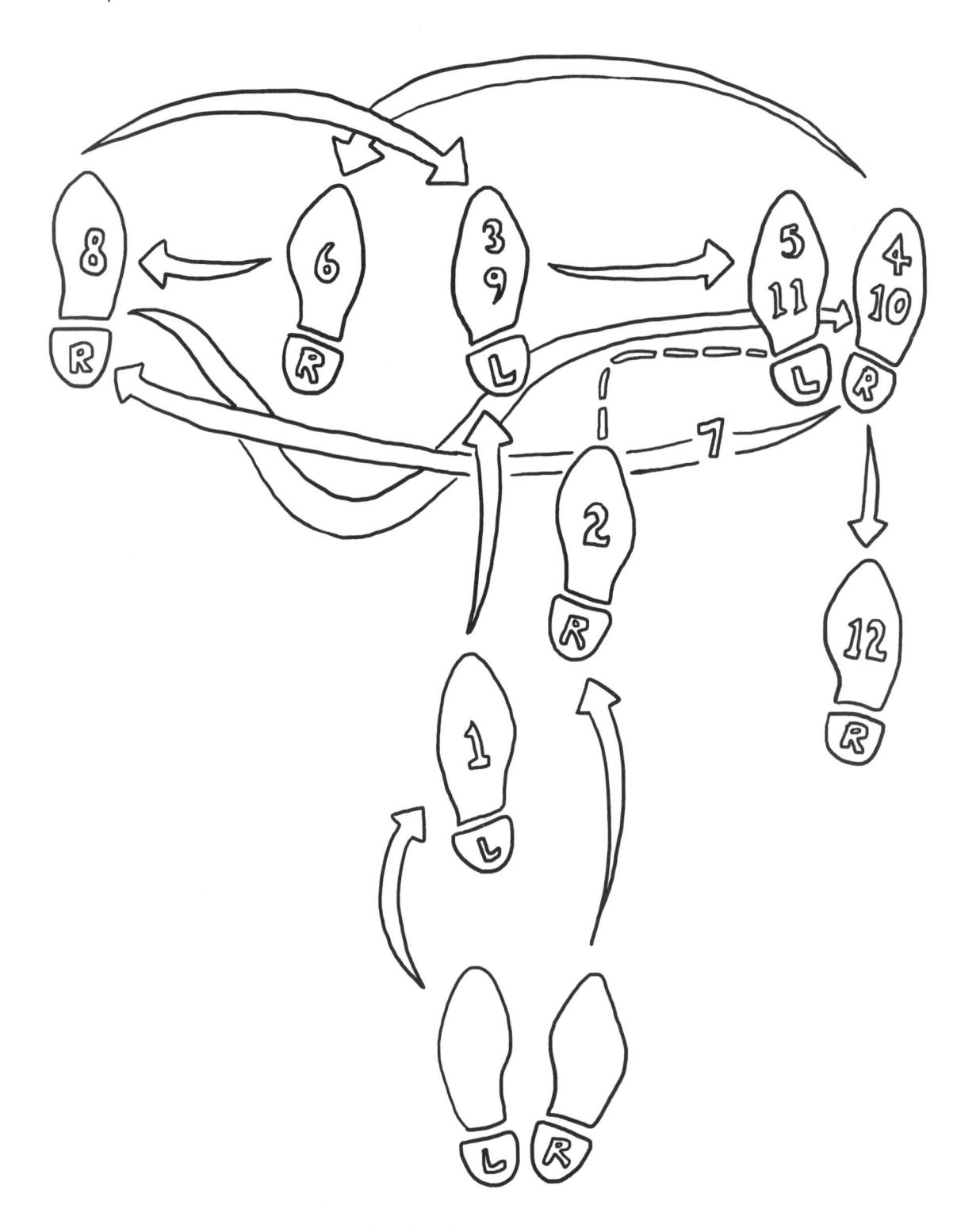

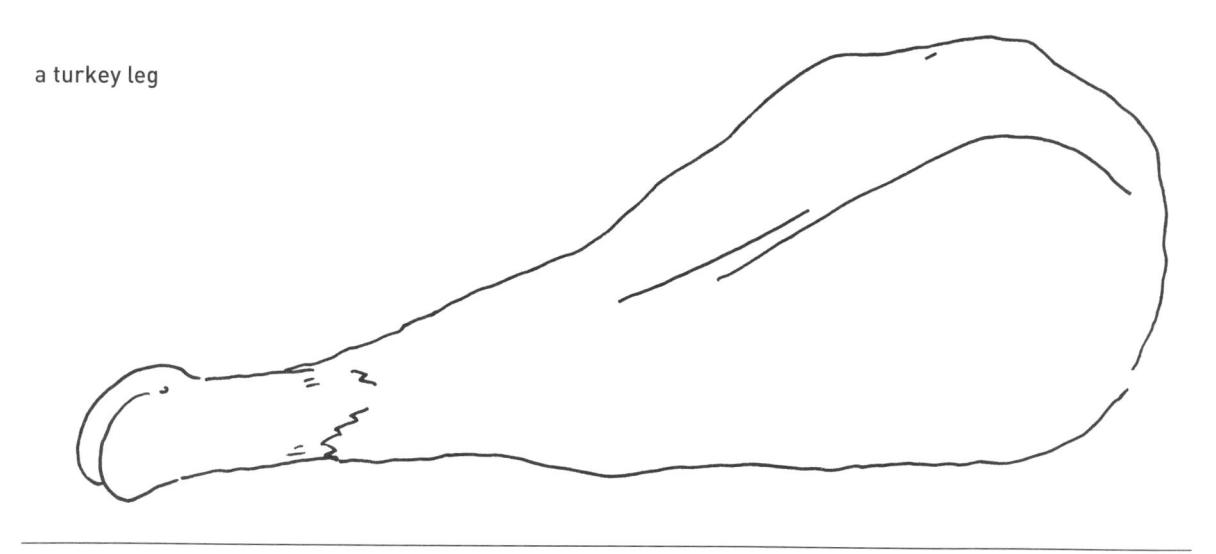

pencils

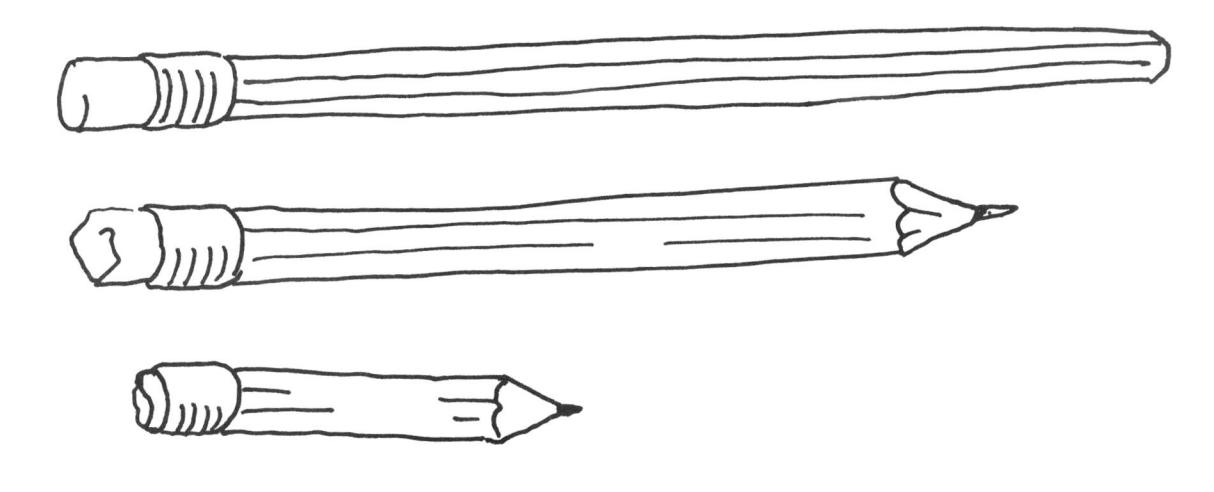

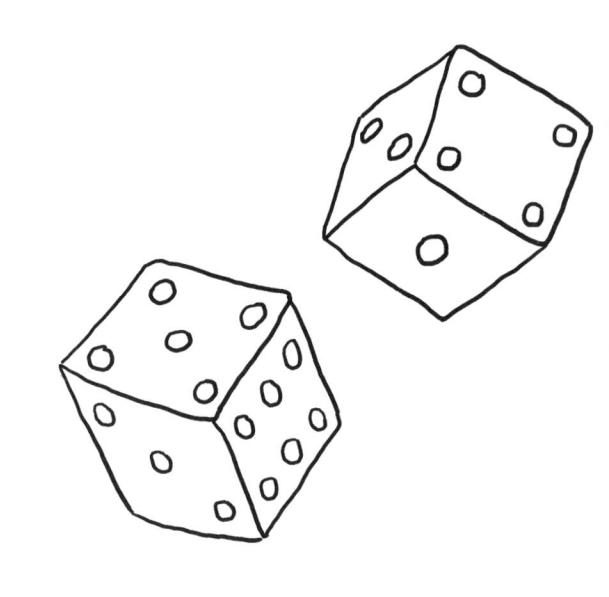

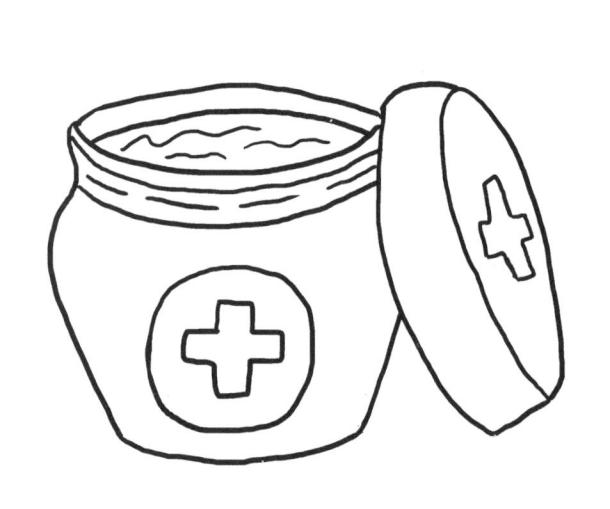

ointment

a library card

a corn dog with mustard

mittens

a pocket

a bunch of grapes

a dirty rag

a scallion pancake

a time machine

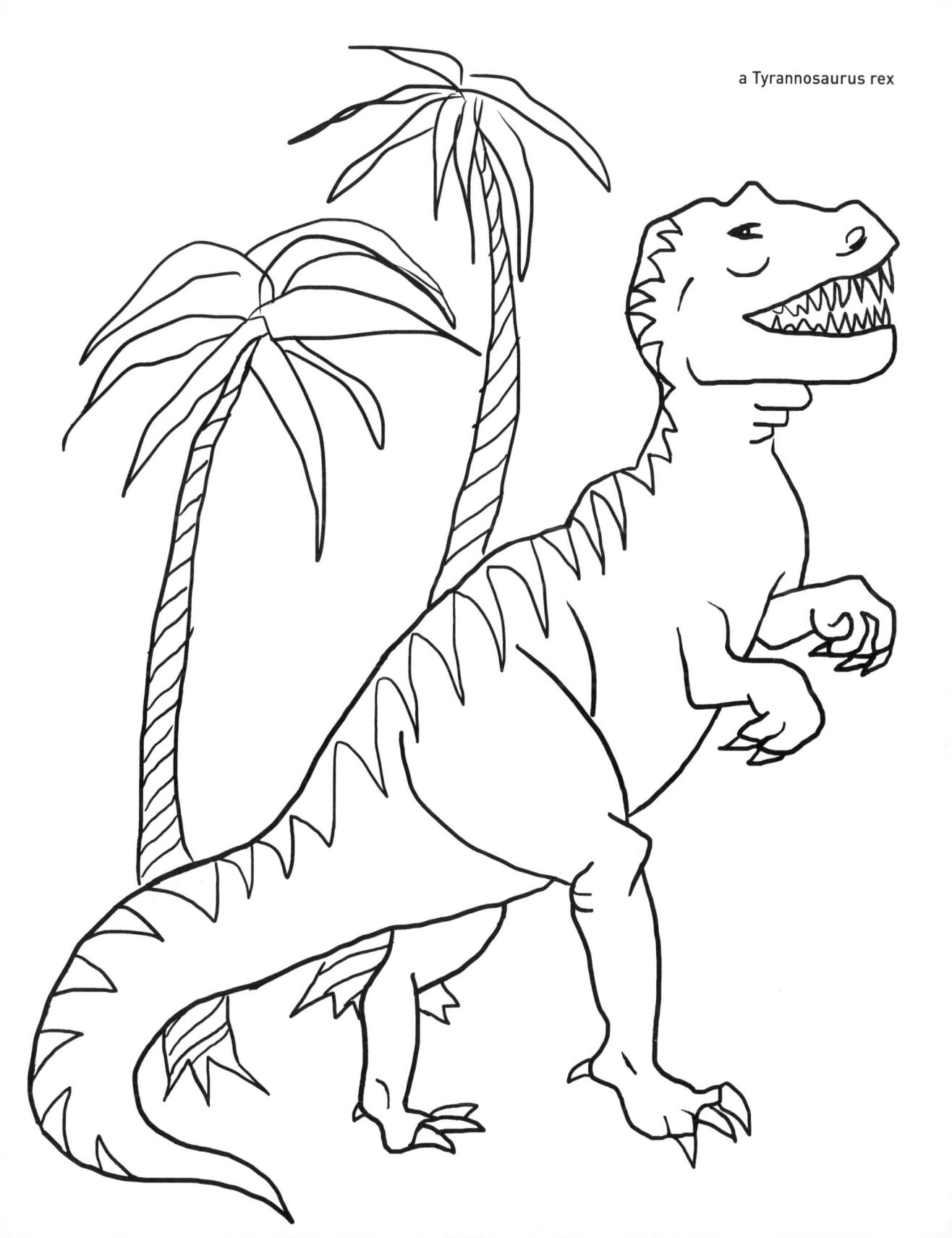

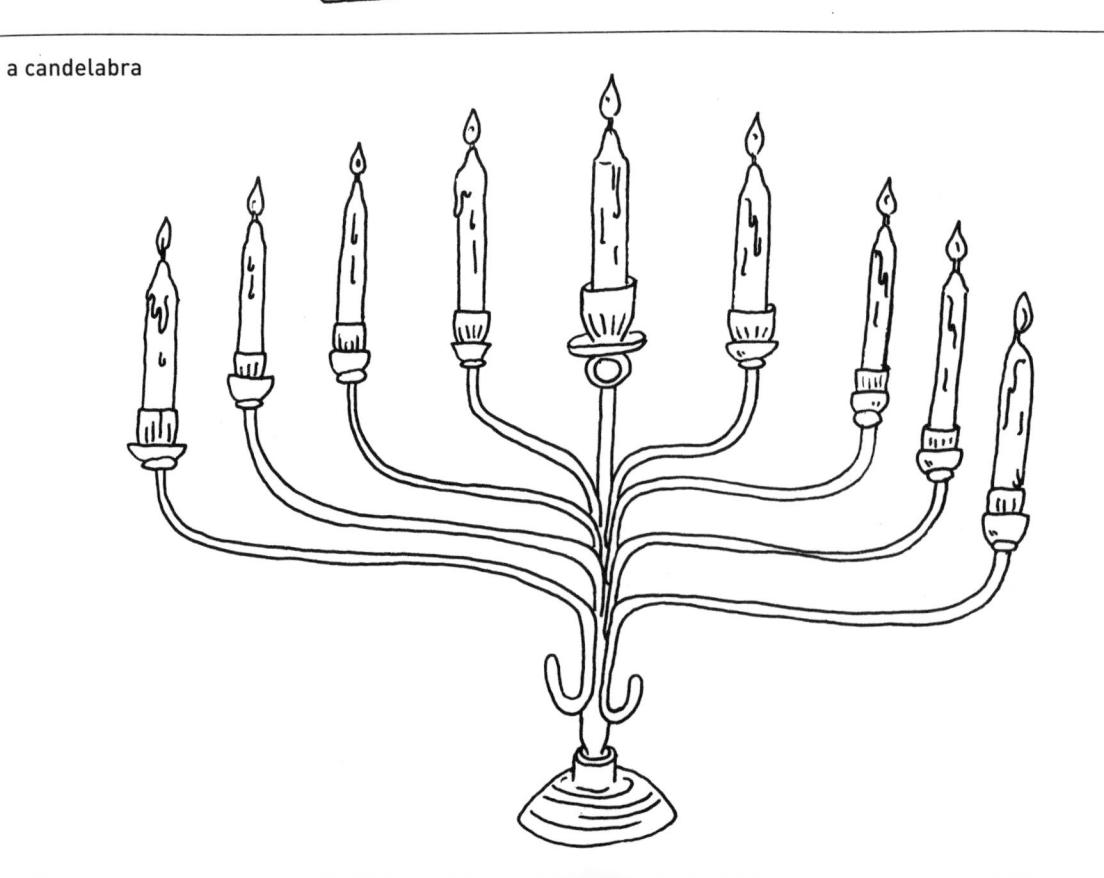

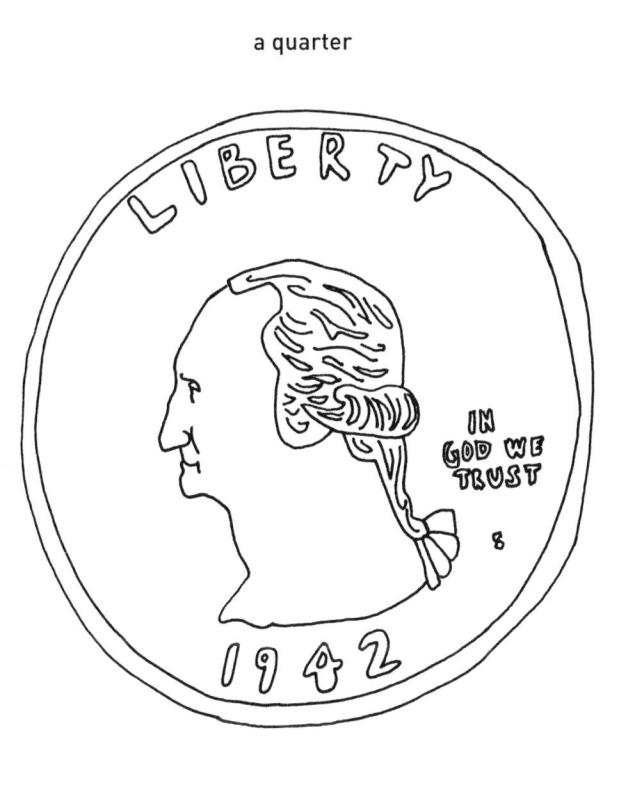

a fairy

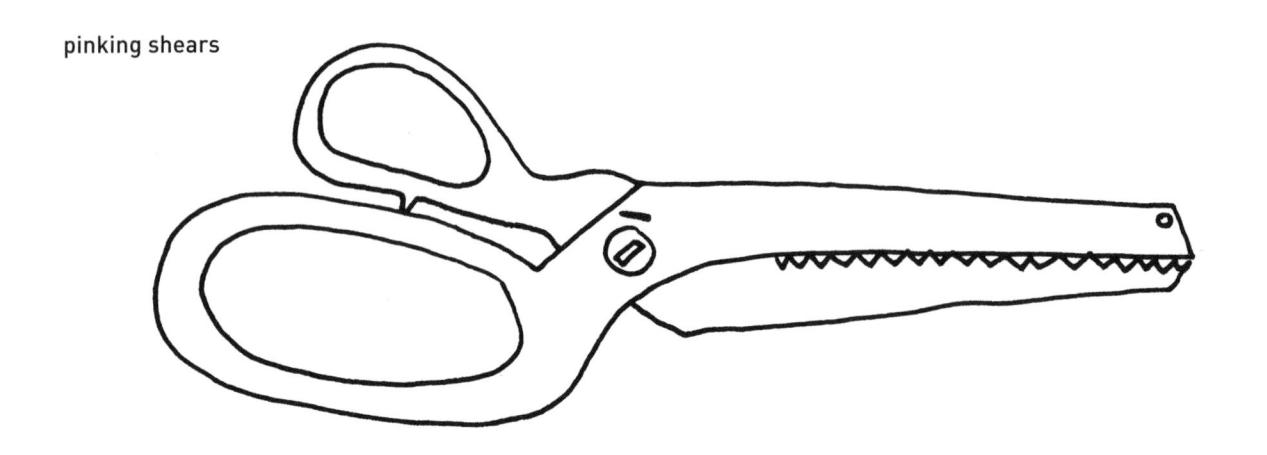

a bandage

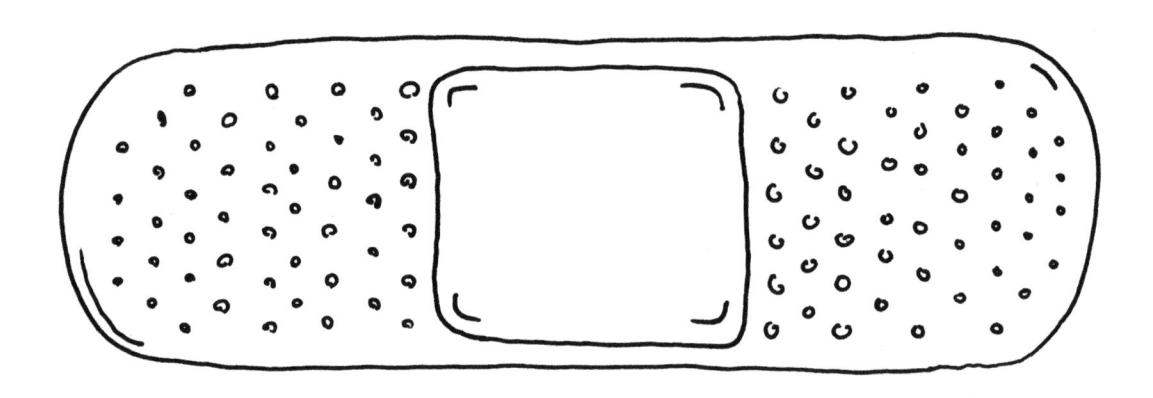

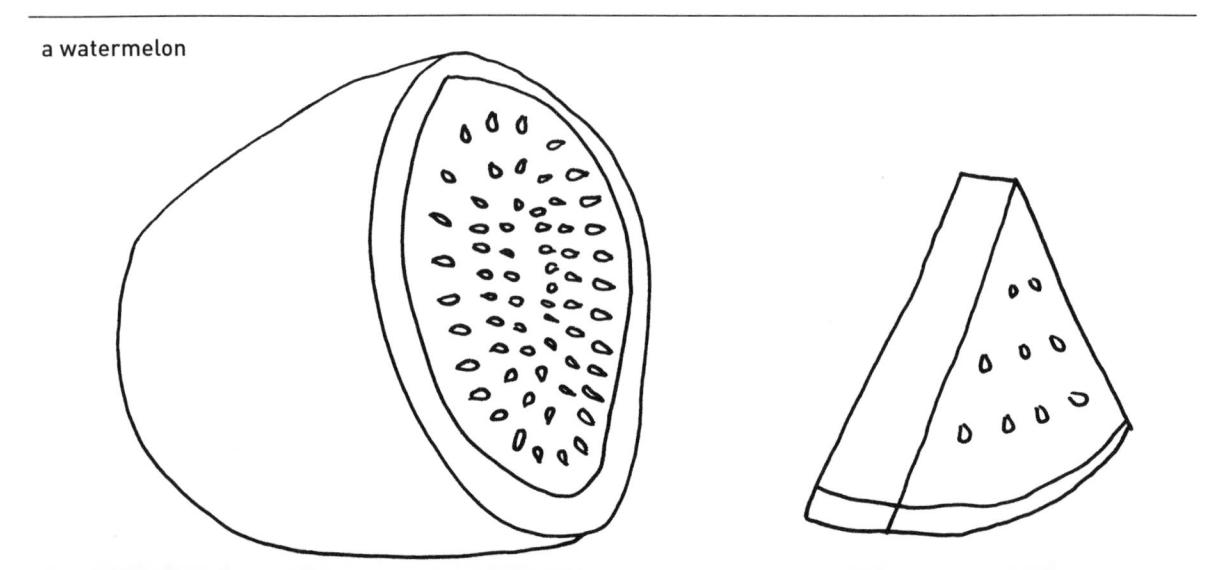

a newsboy cap

a pea pod

a daffodil

an onion

a slinky

a keychain

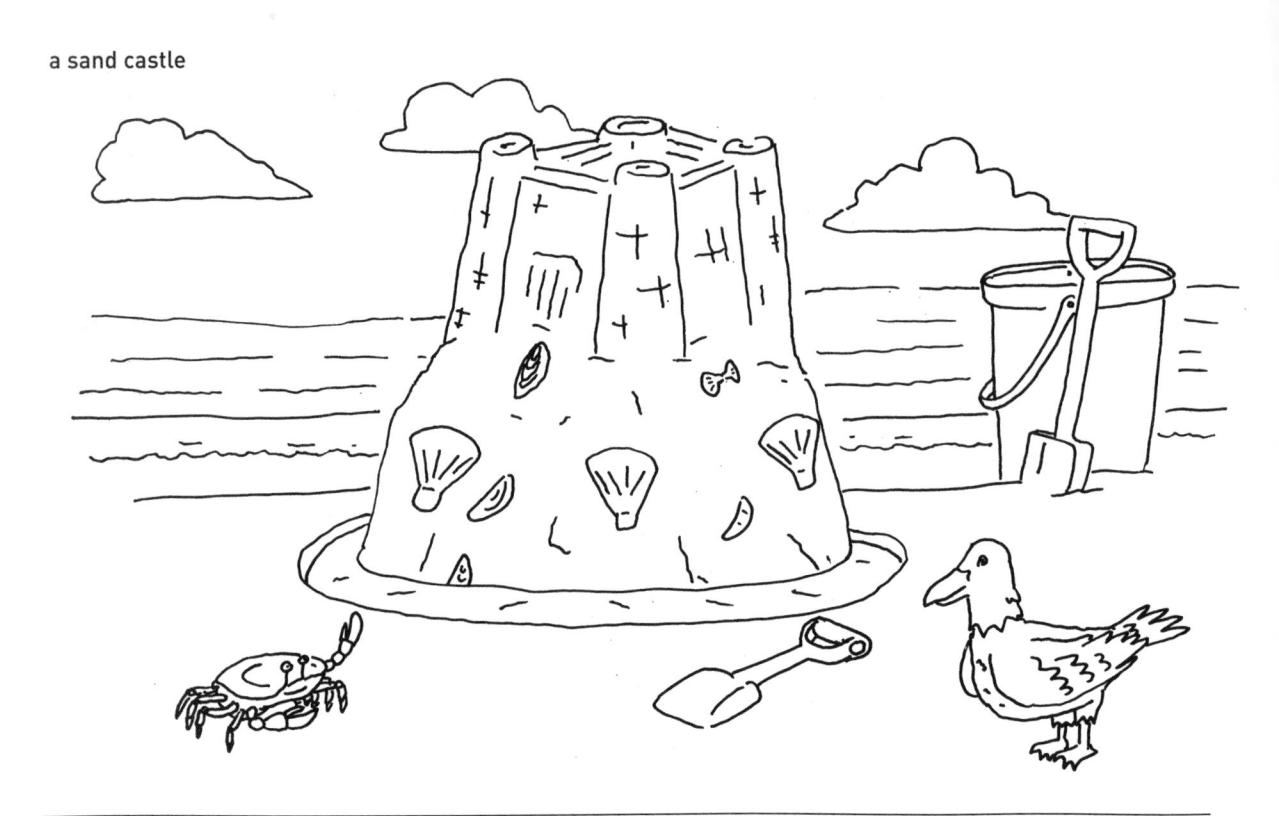

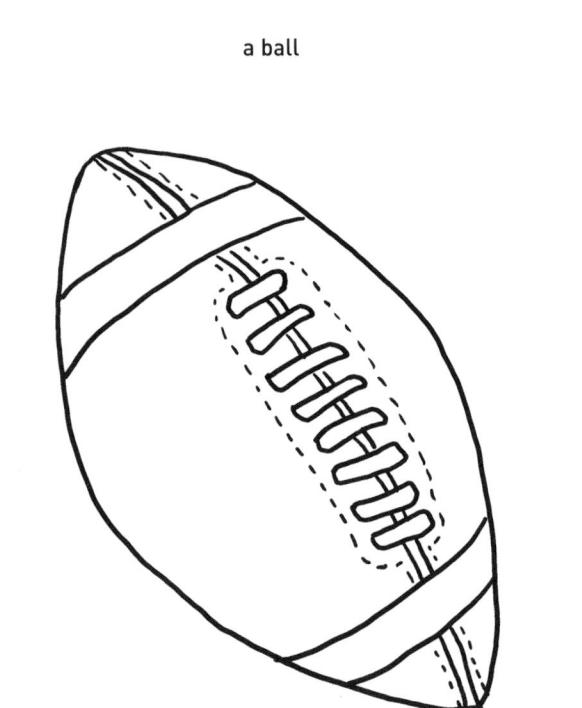

a horseshoe

a pug

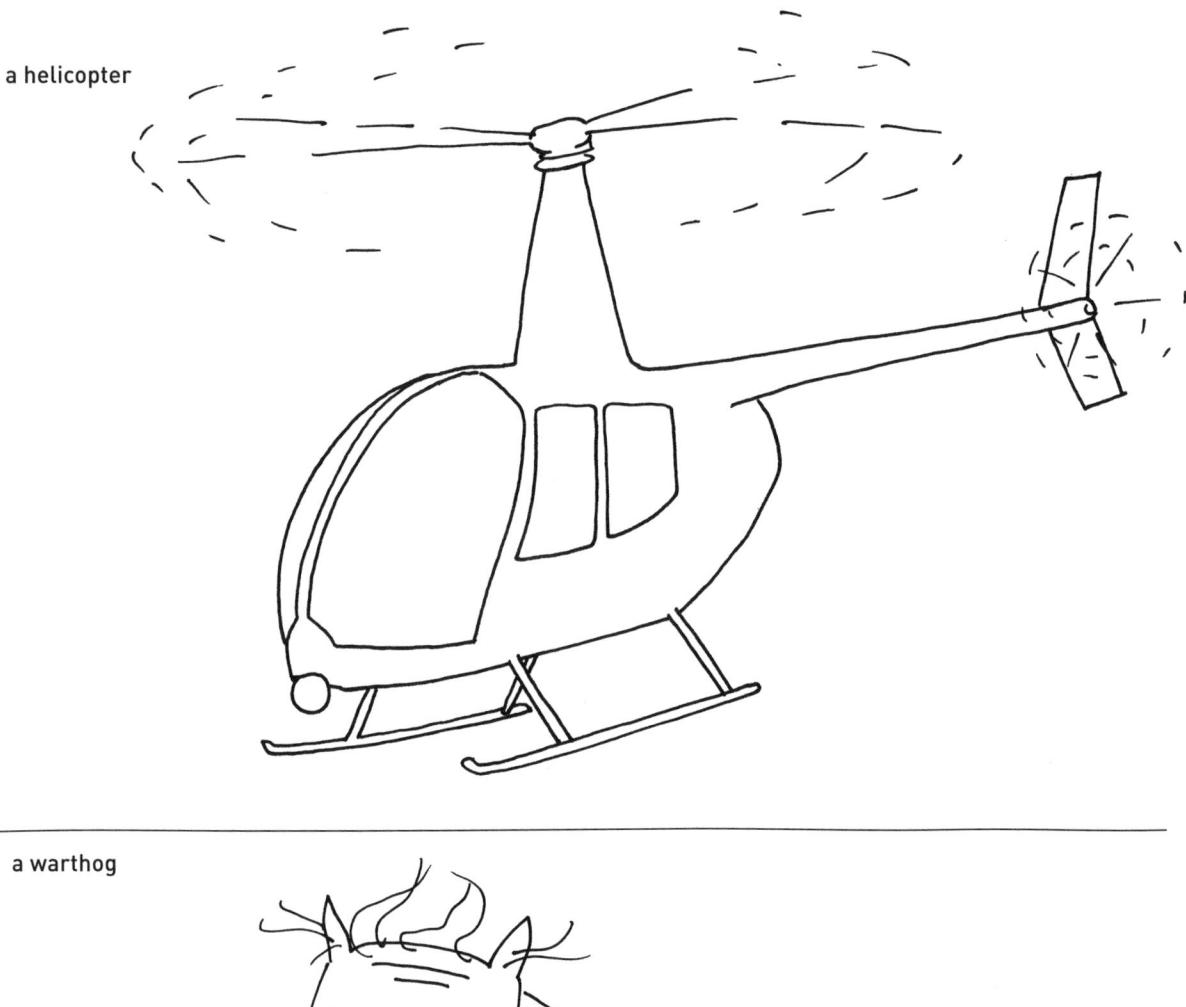

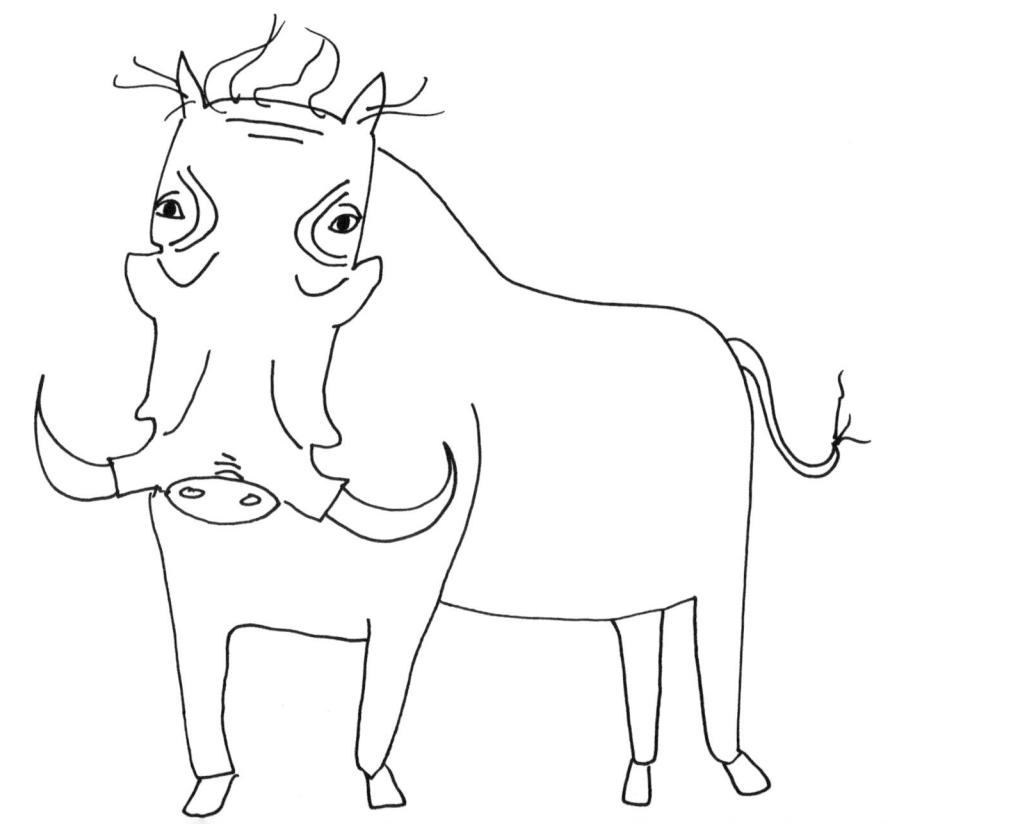

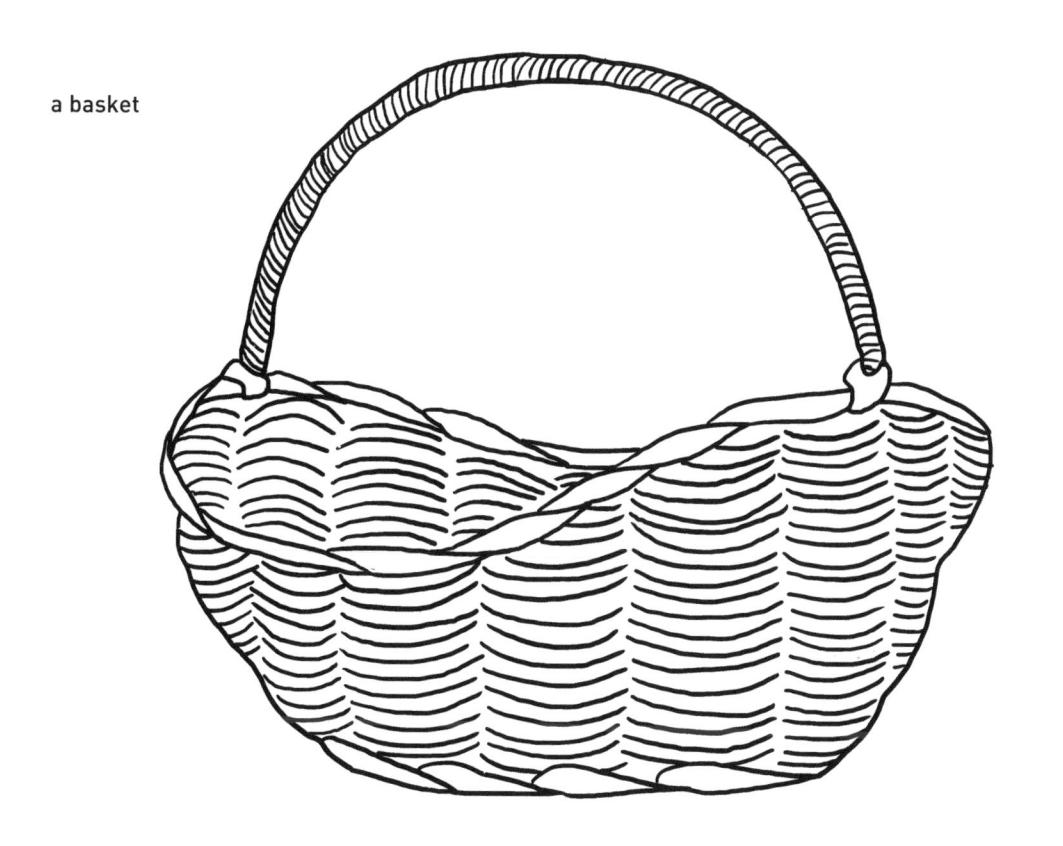

a skateboard

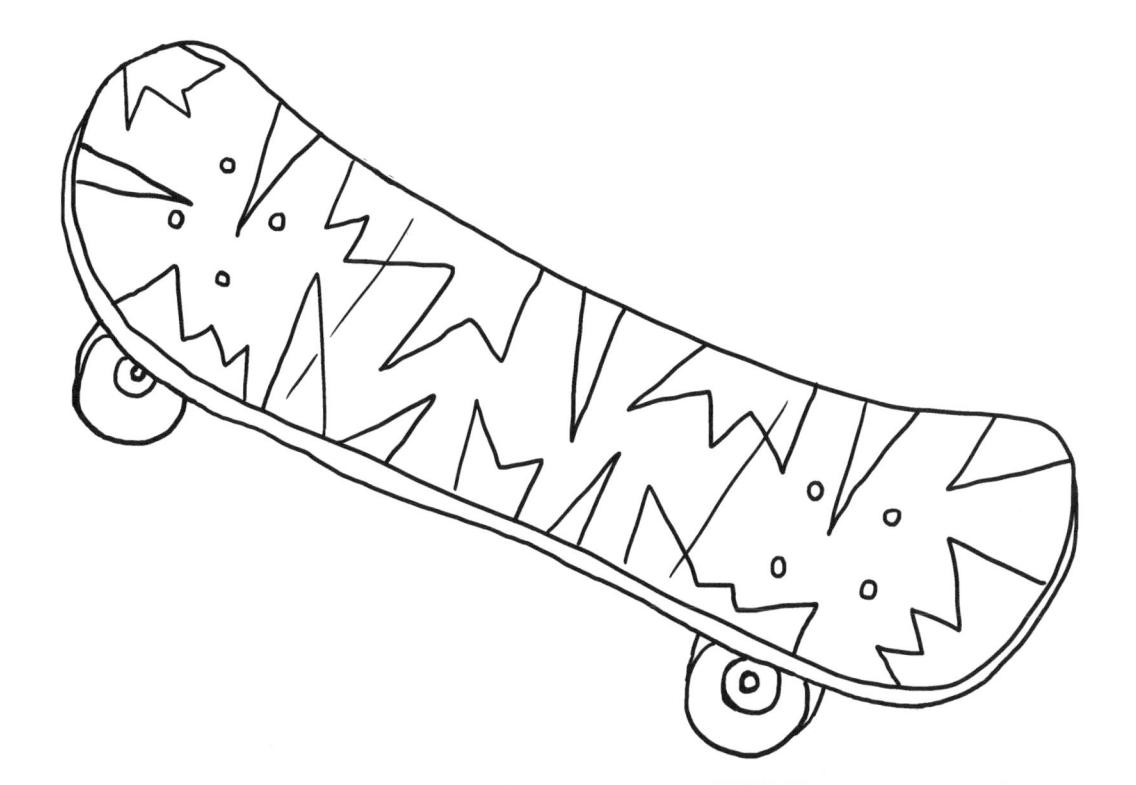

a hamburger

sunglasses

a seal

handprints

a rotary phone

a top hat

a turtle

a baseball

a marble

a weathervane

a lunchbox

a pound

cat whiskers

a cleaver

a Quonset hut

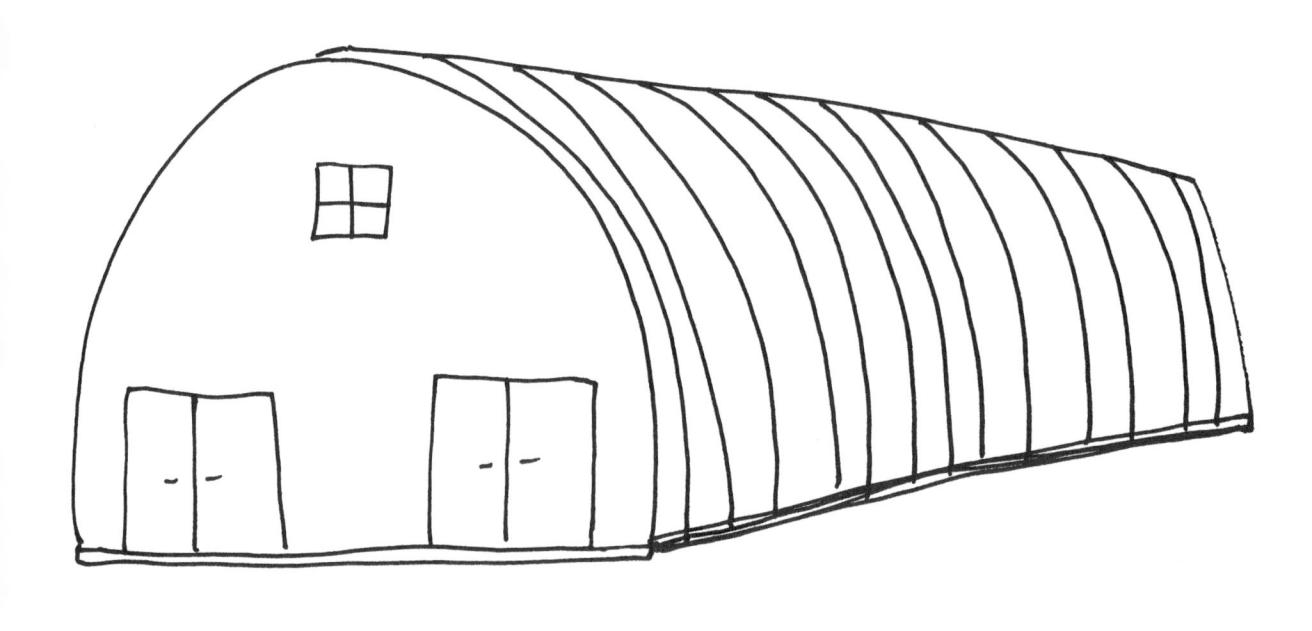

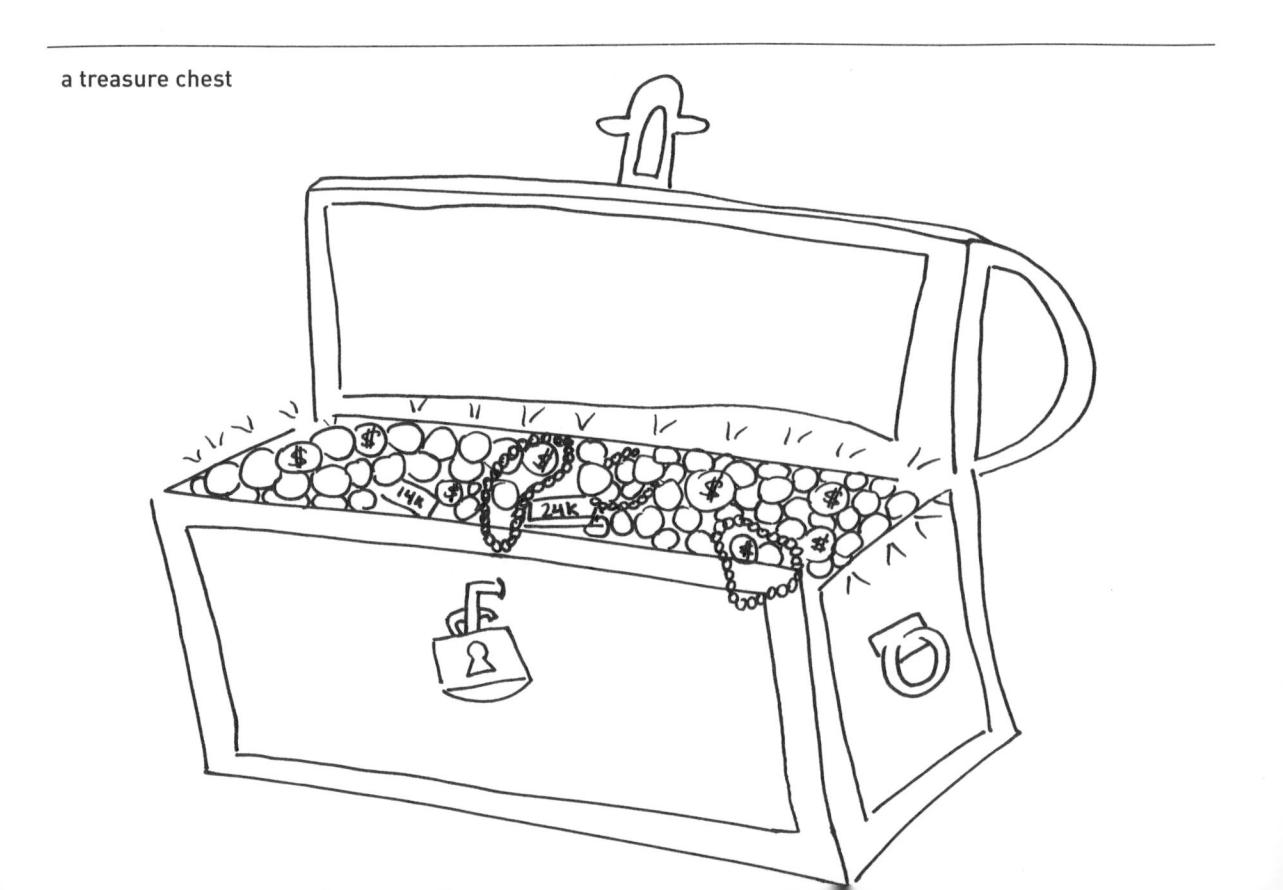

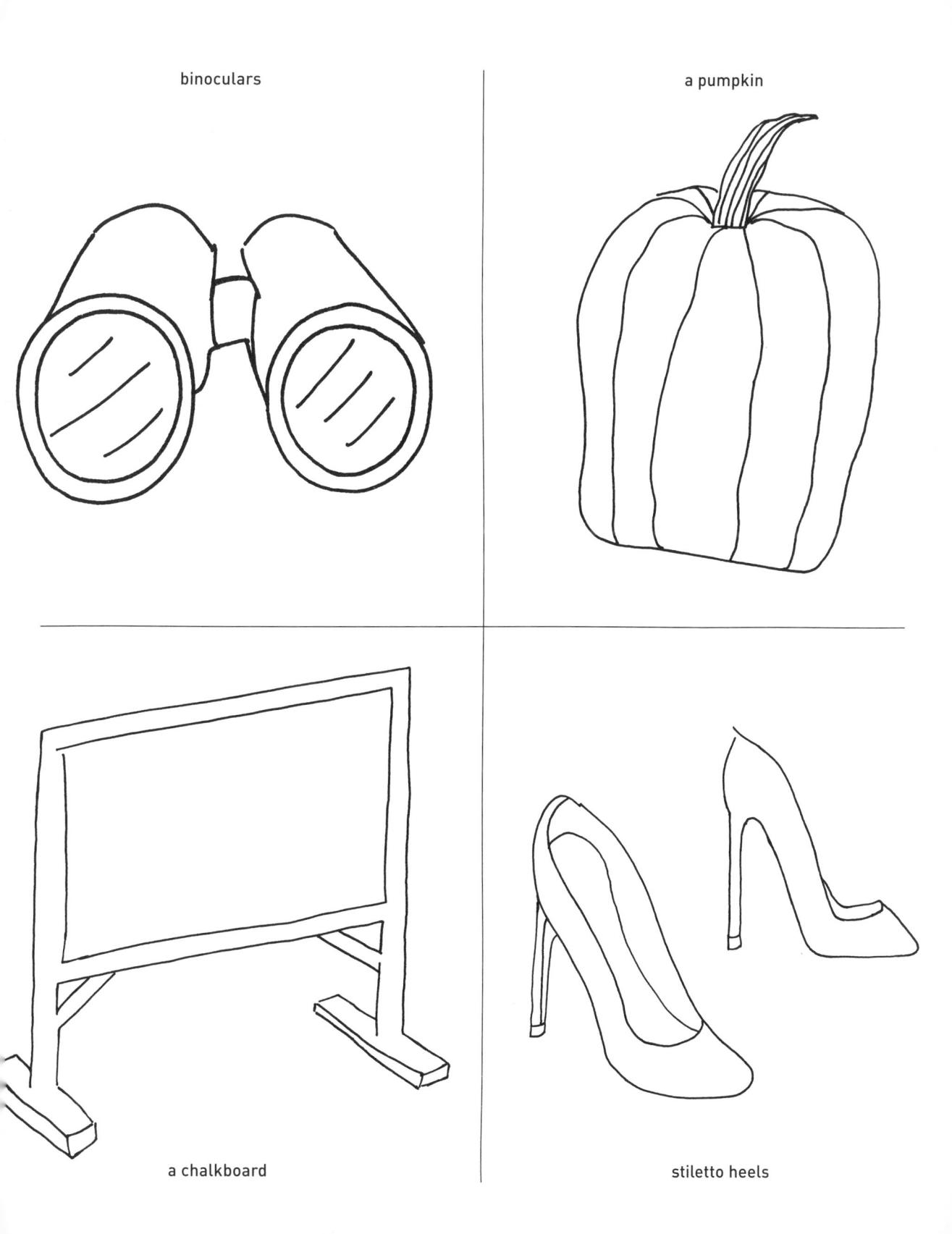

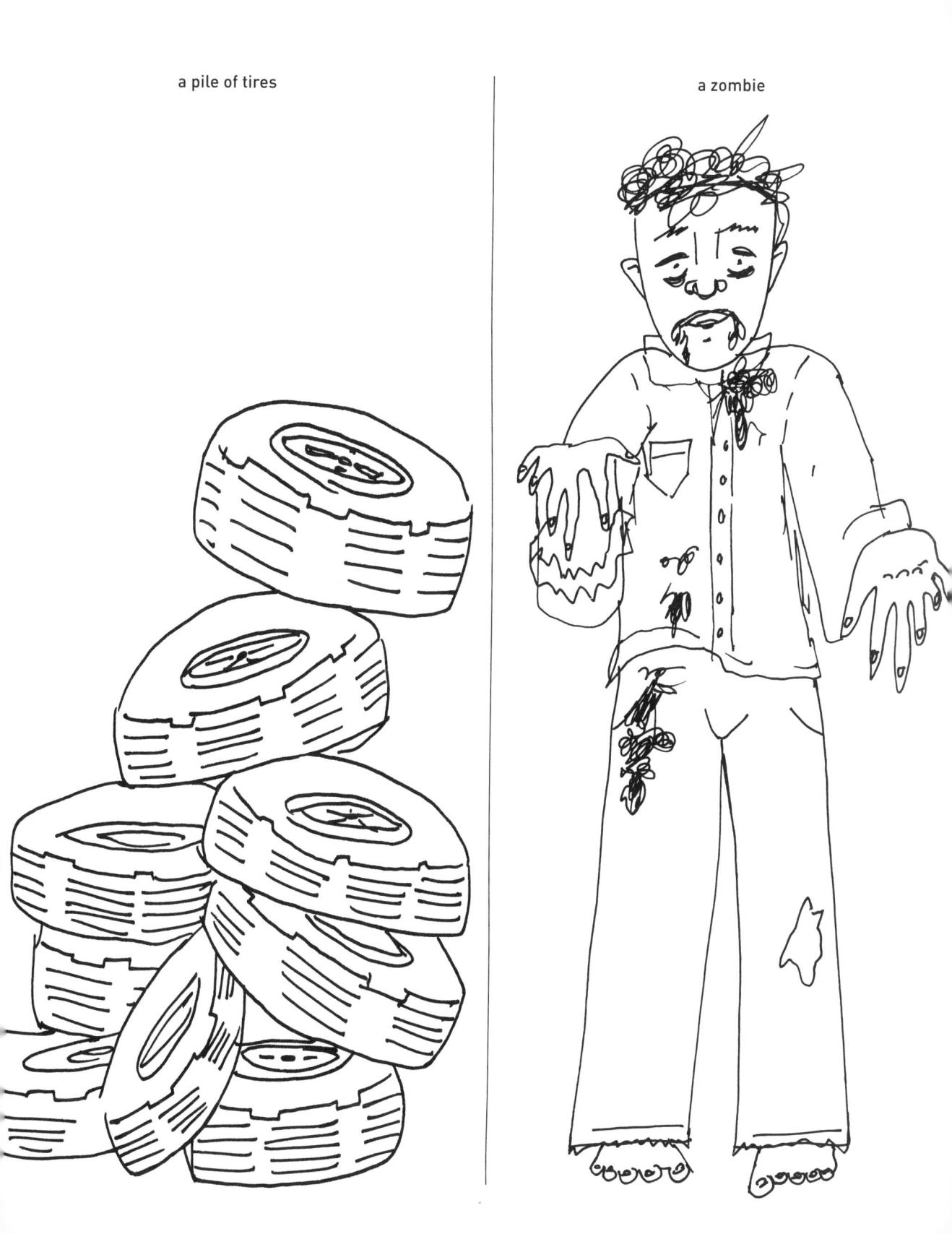

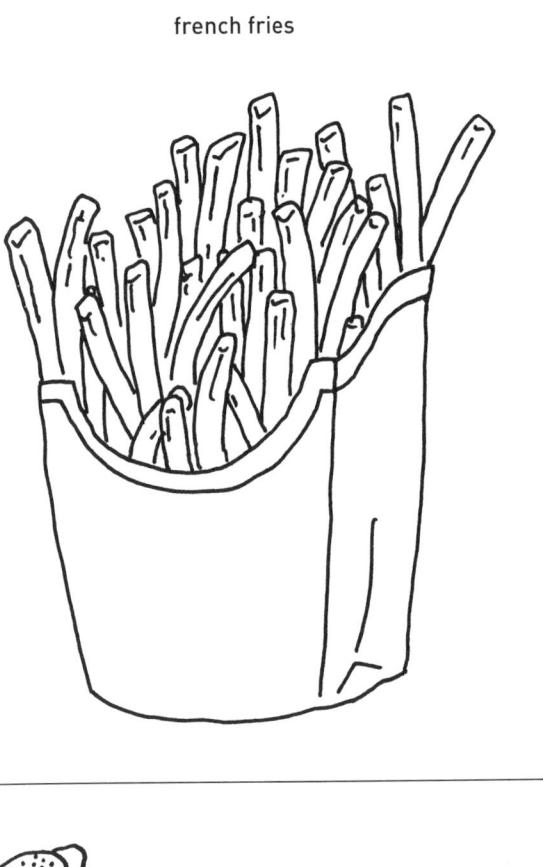

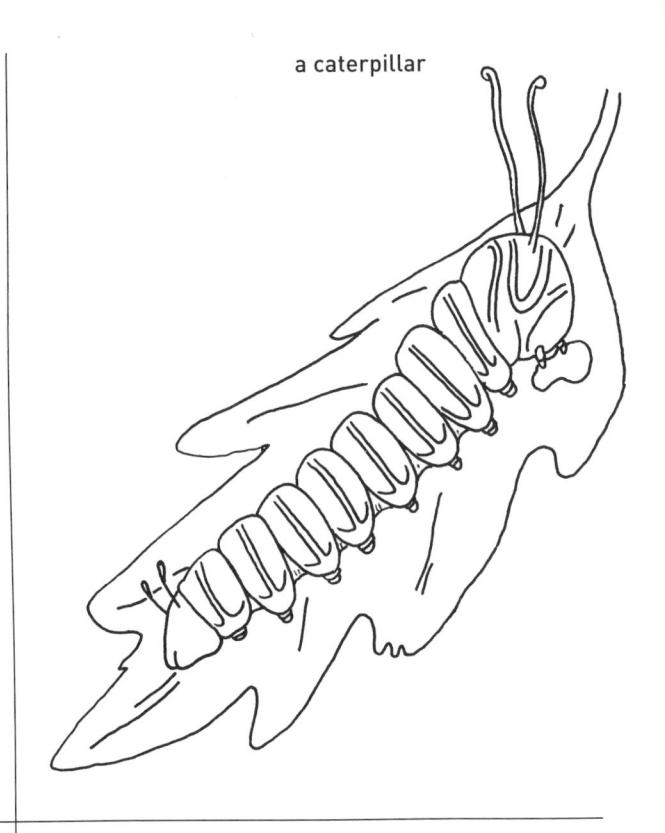

a cactus

playing cards

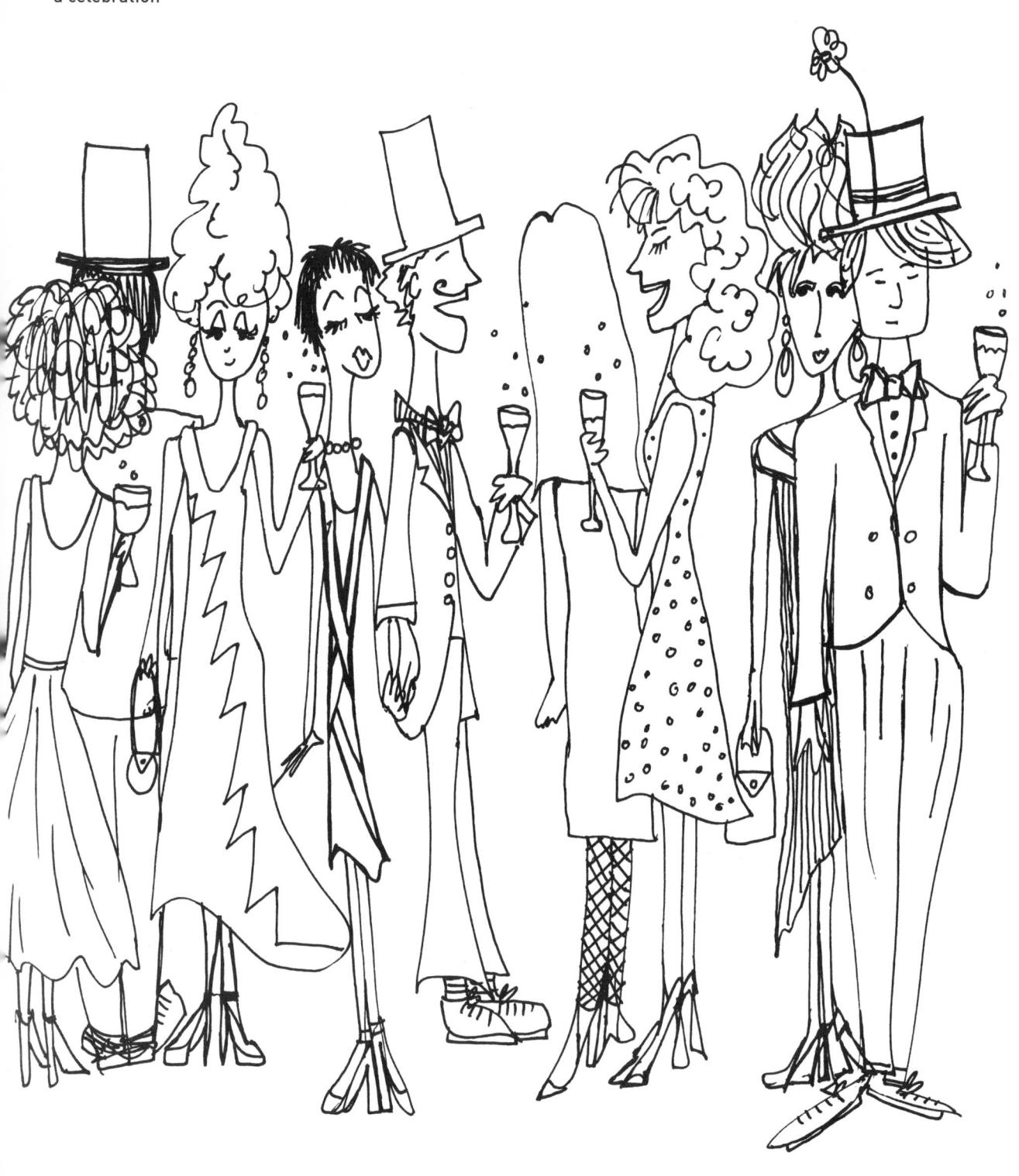

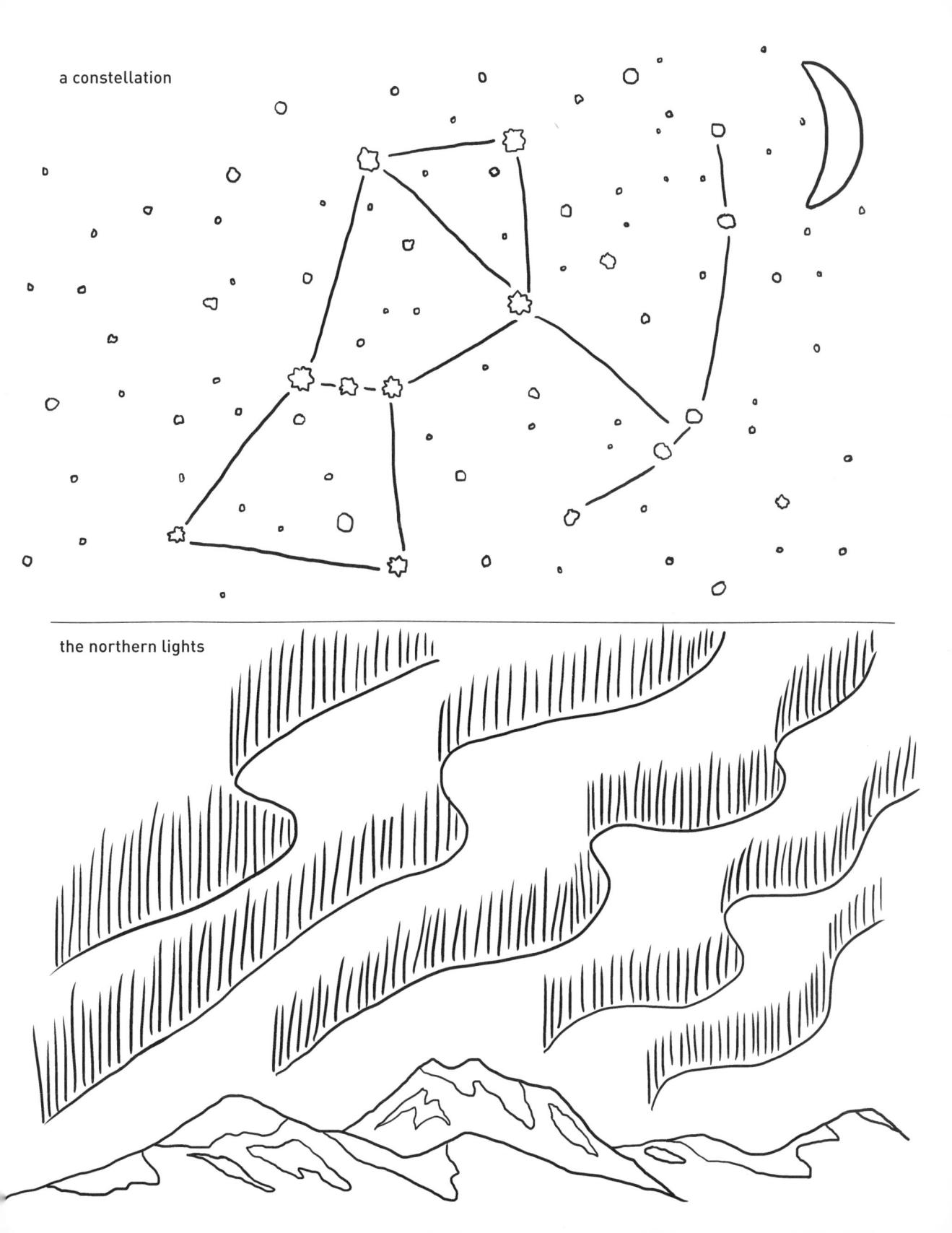

a wink

an inchworm

a box of tissues

a balloon animal

a spiral-bound notebook

a salt shaker

a bearded lady

a box of kittens

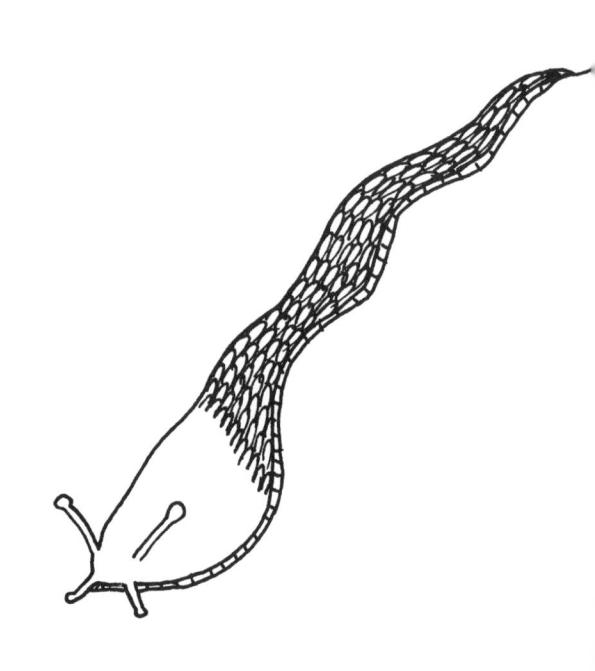

a slug

a spoon

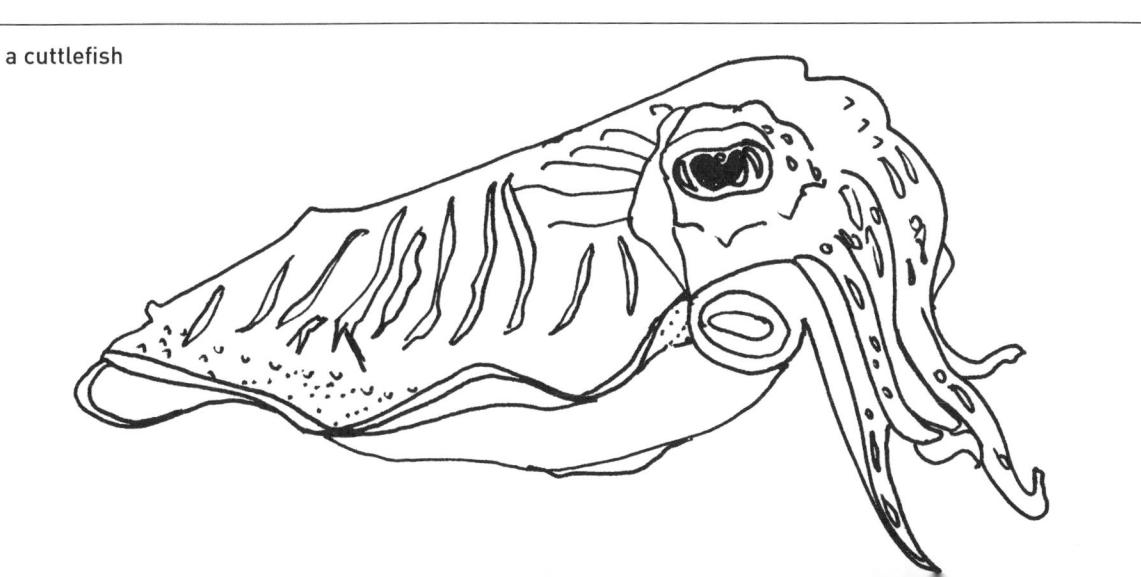

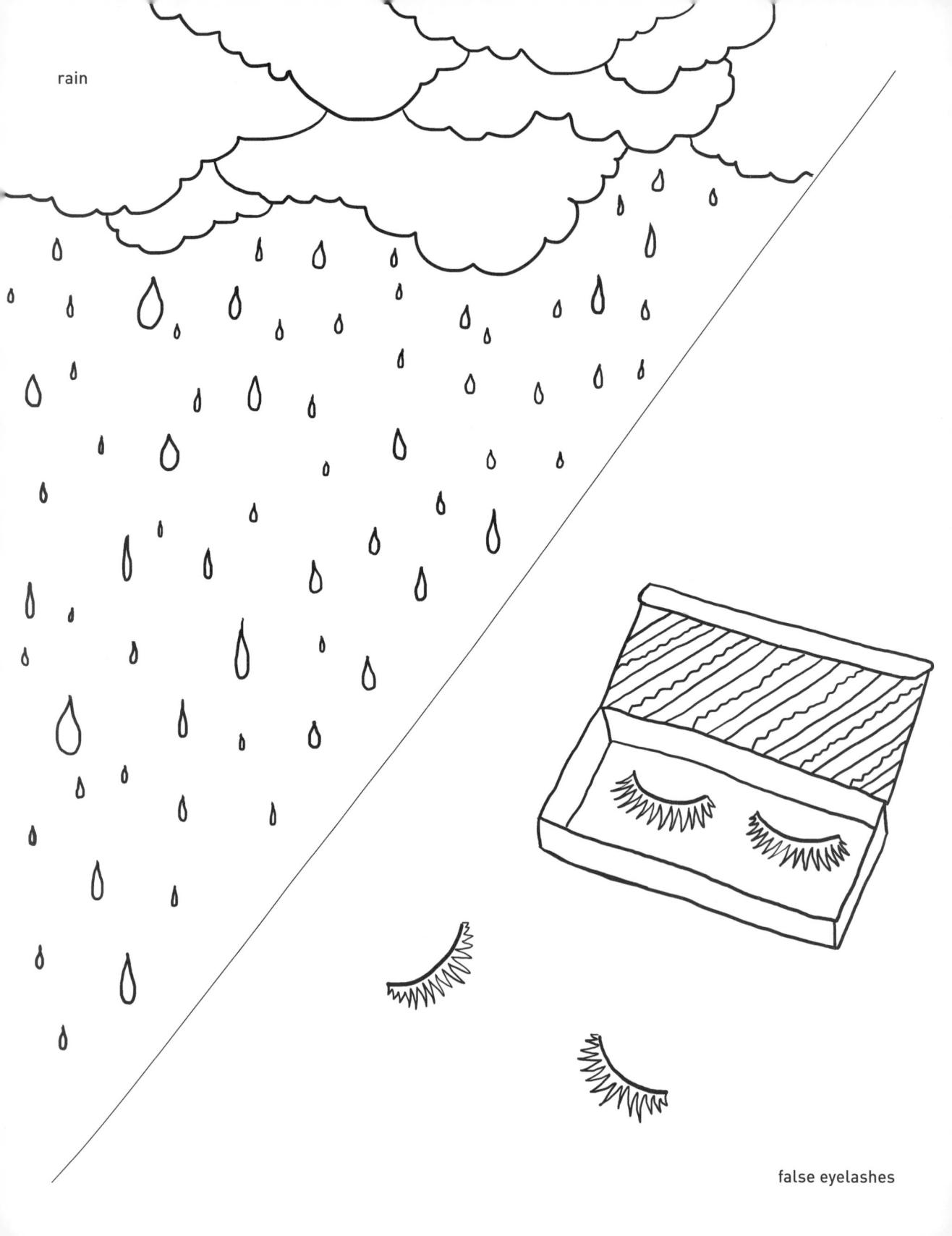

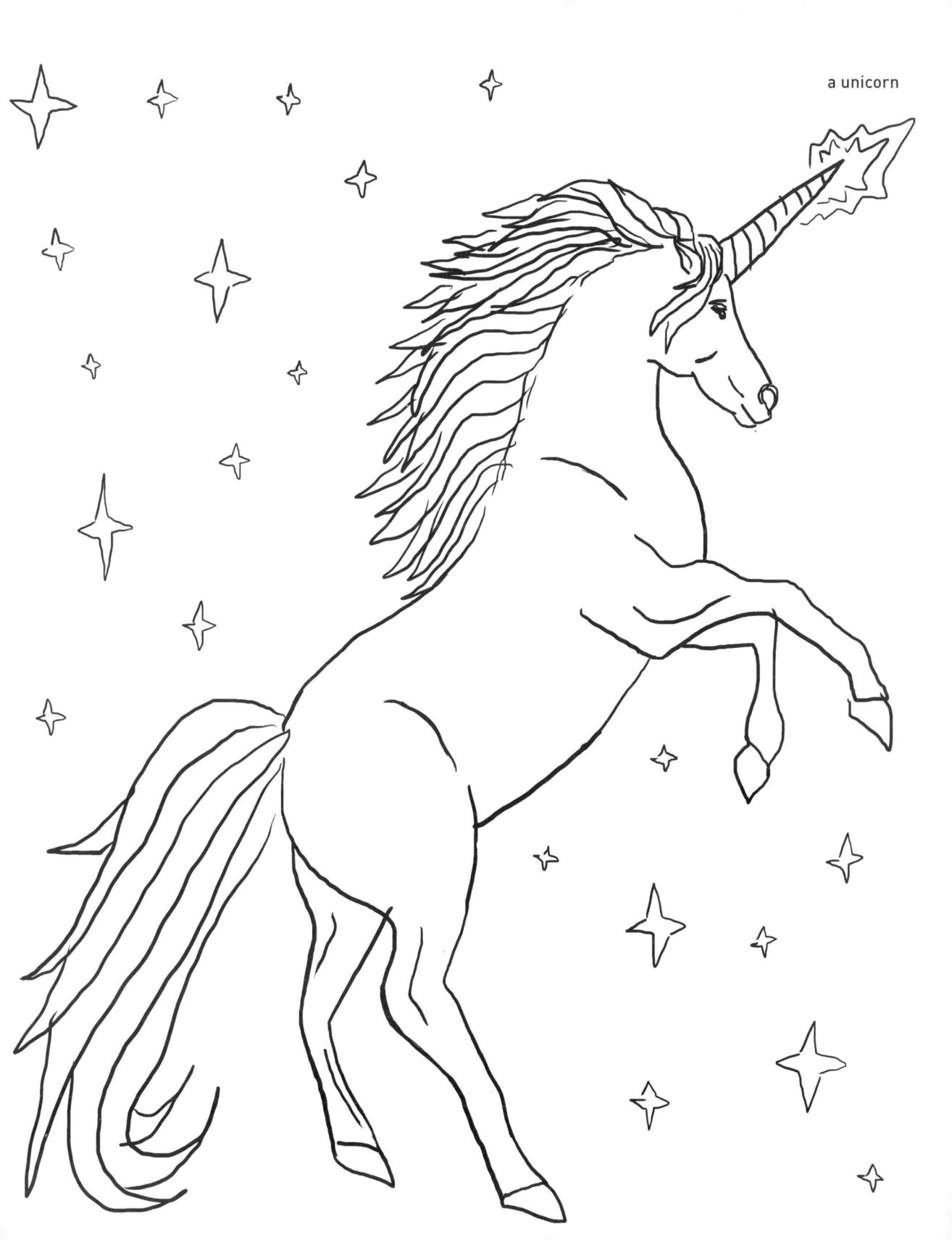

a diaper

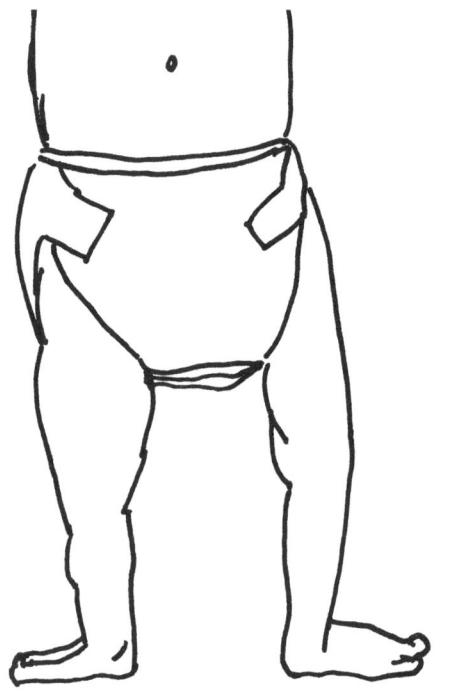

a bottle cap

Queen Victoria

a bird feeder

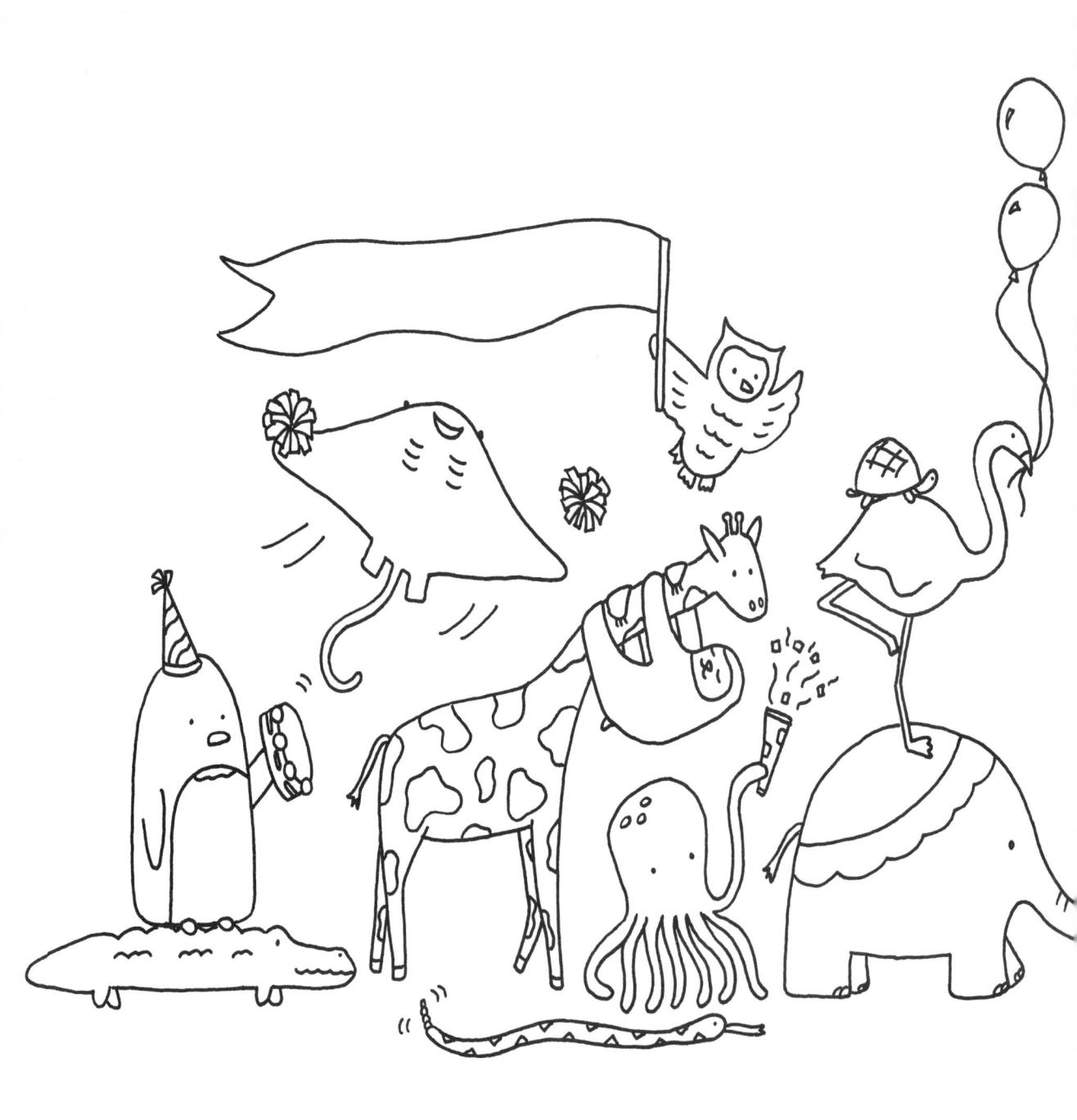

a sarcophagus

a sled

a flattop

a baseball glove

a milk carton

a diamond ring

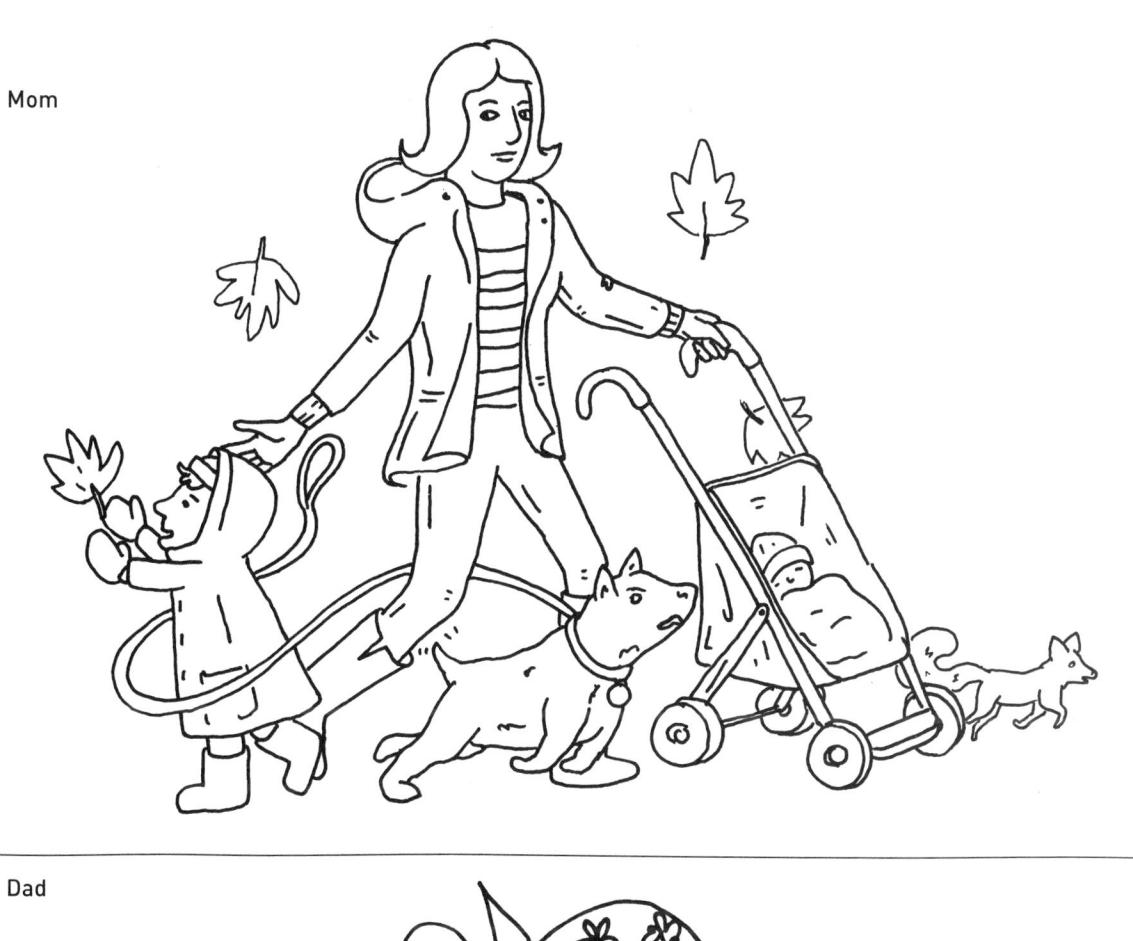

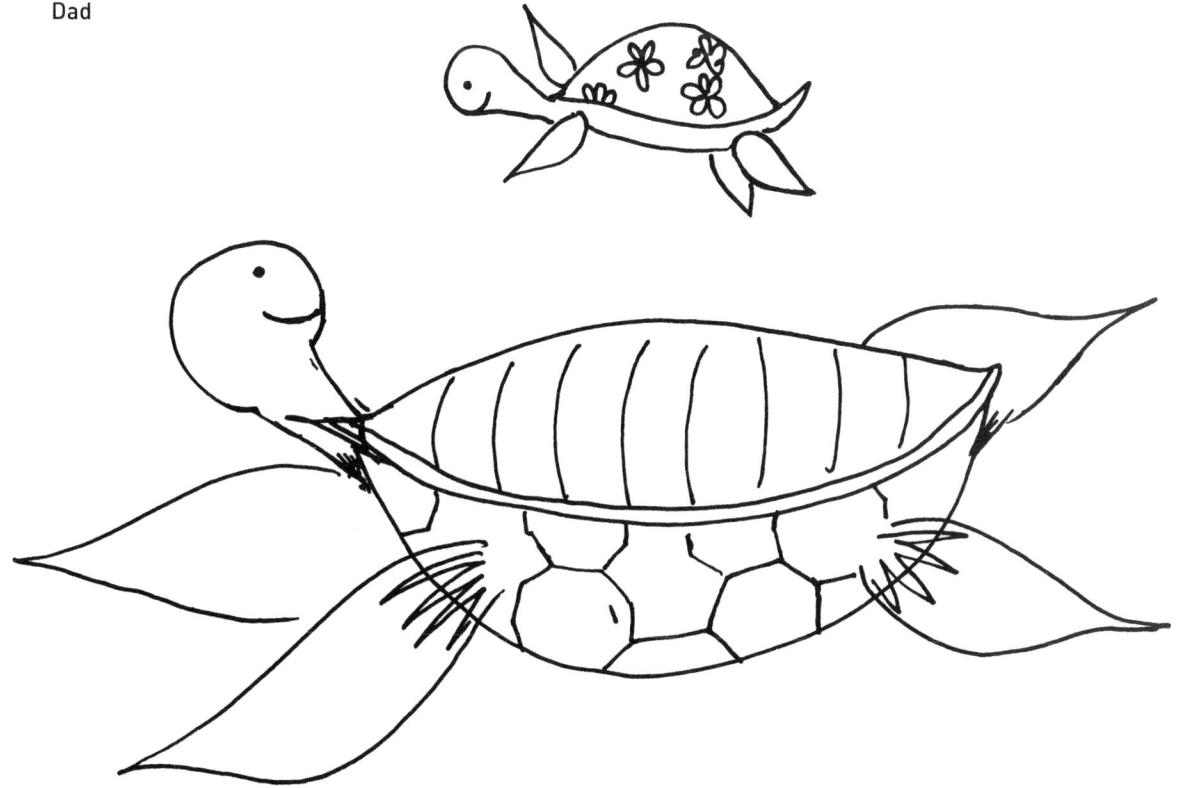

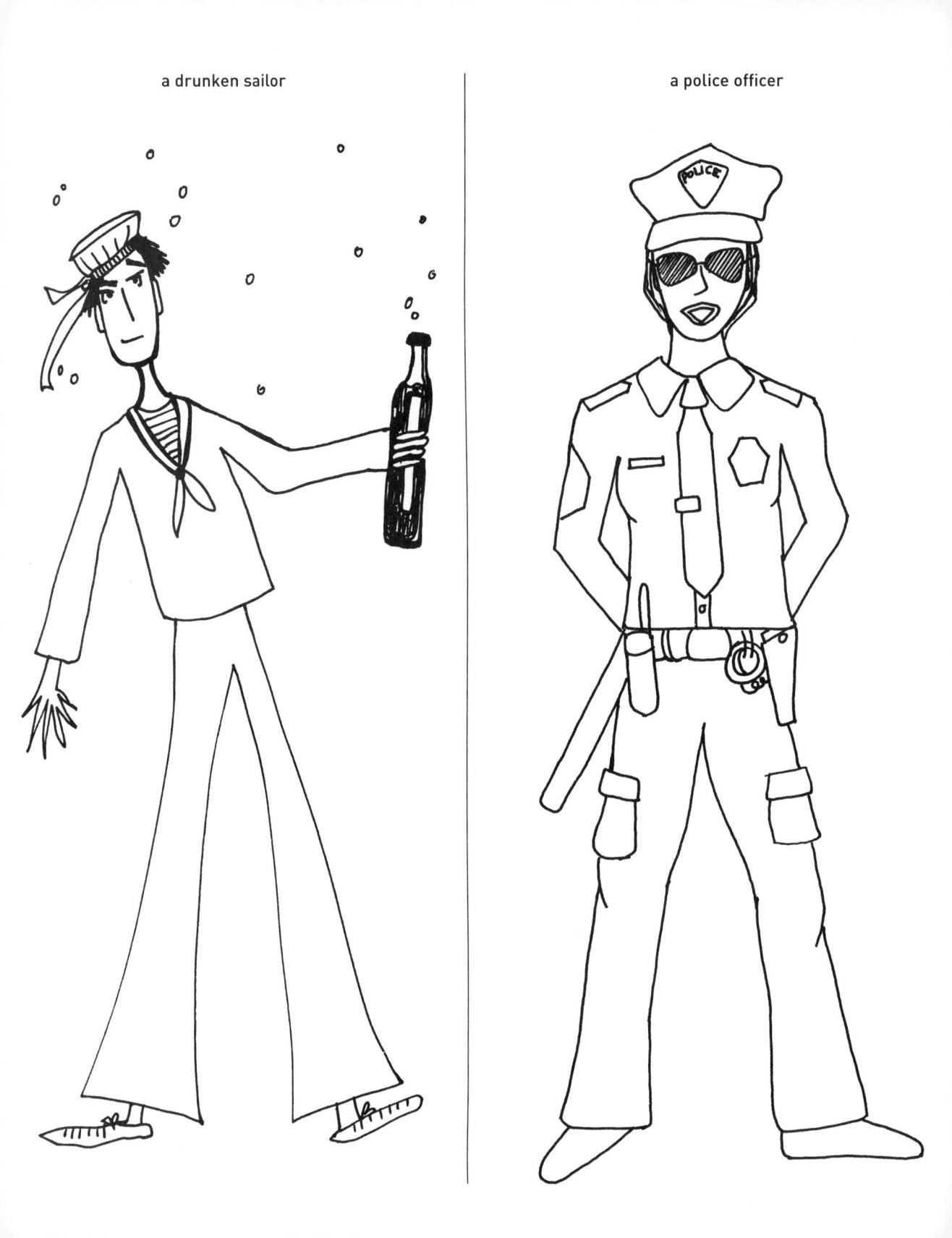

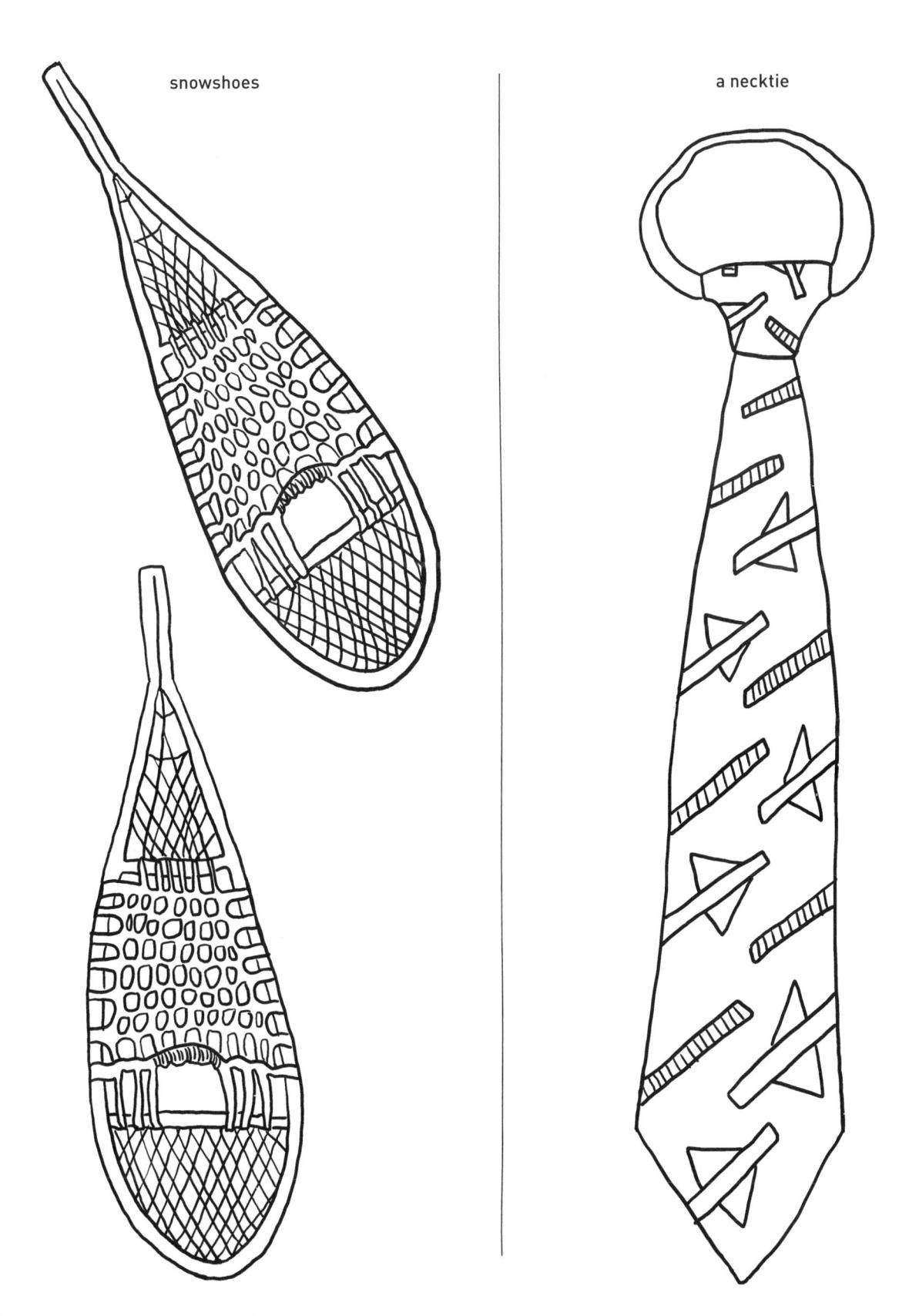

a bowler hat

a unicycle

a frog

a paper coffee cup

an open/closed sign

knitting needles

a little prince

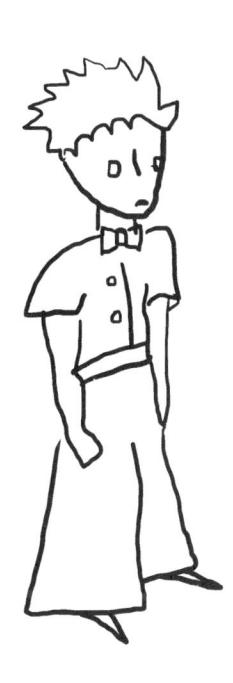

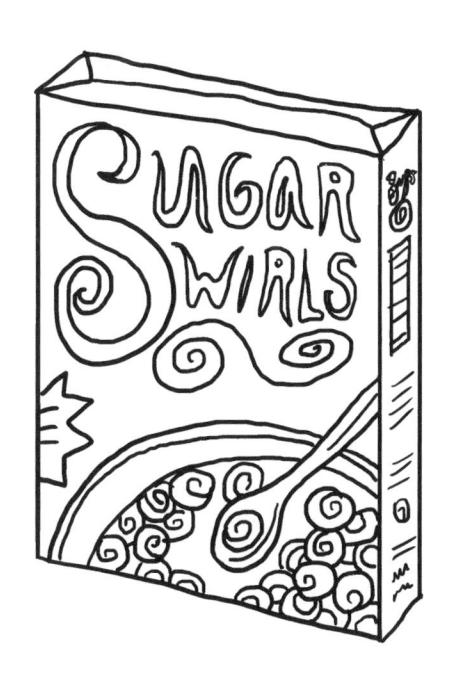

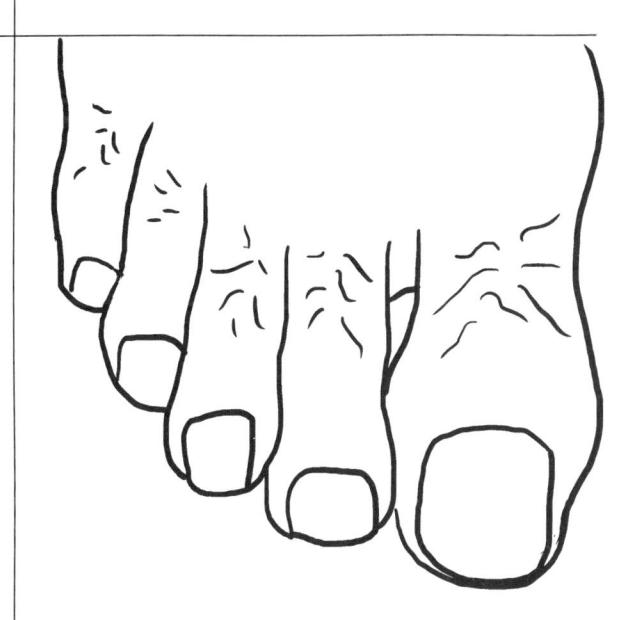

a box of cereal

toes

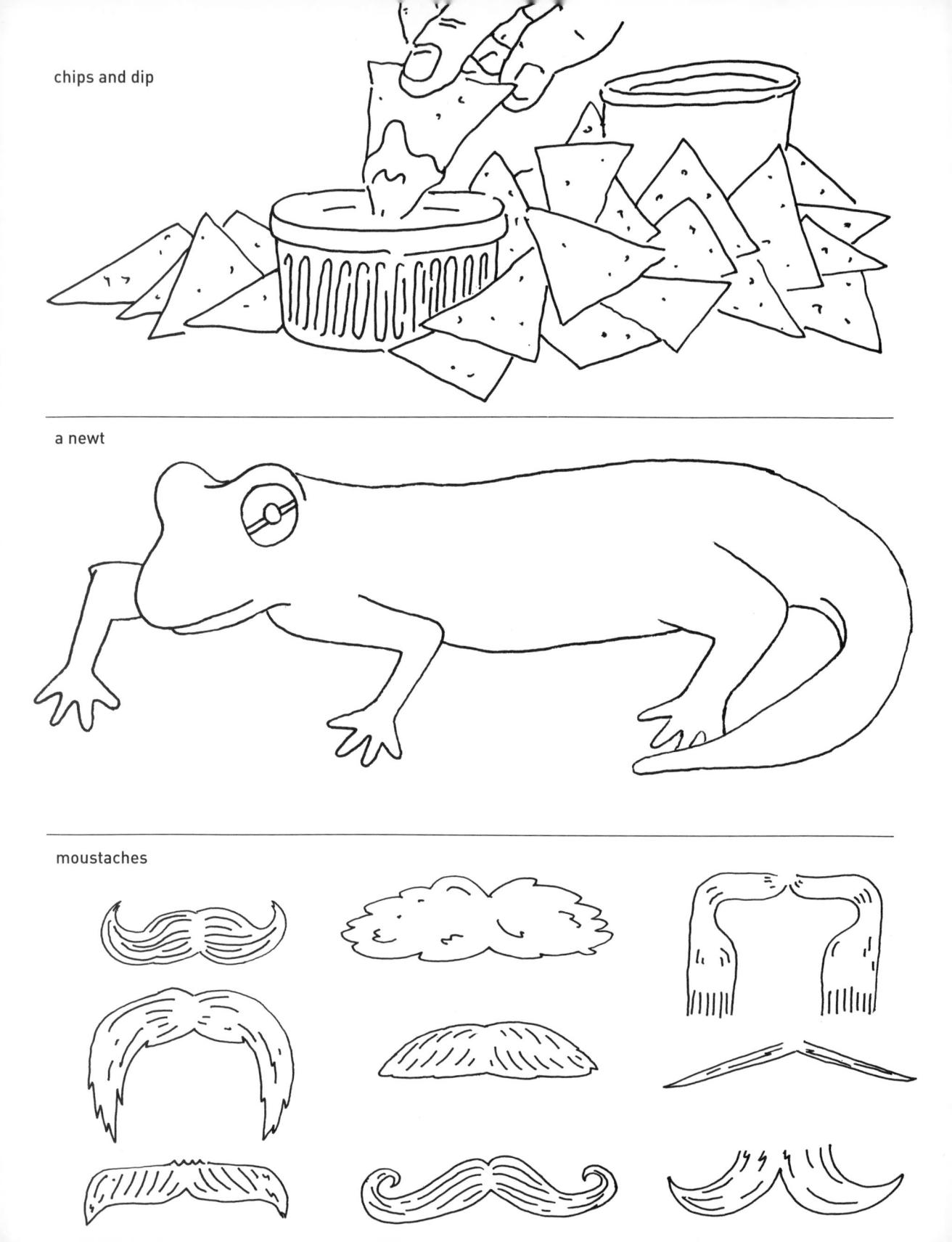

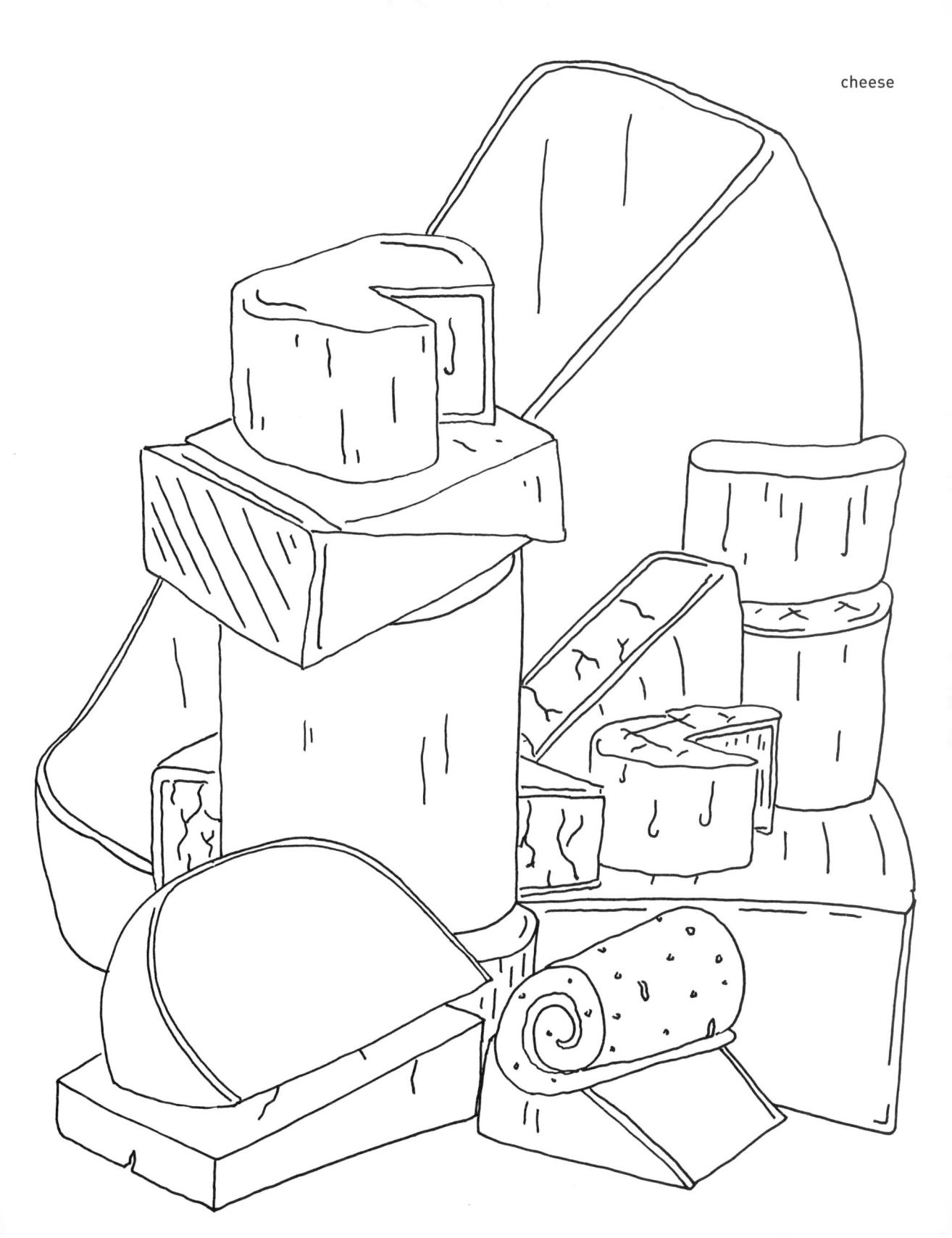

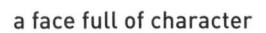

an ugly duckling

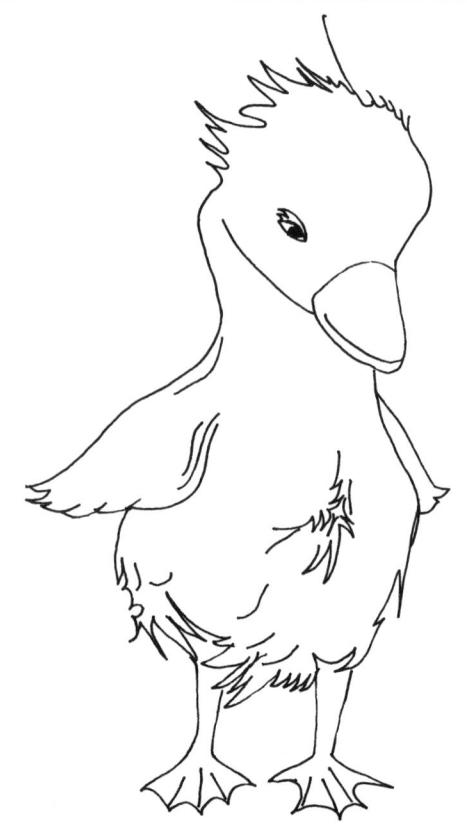

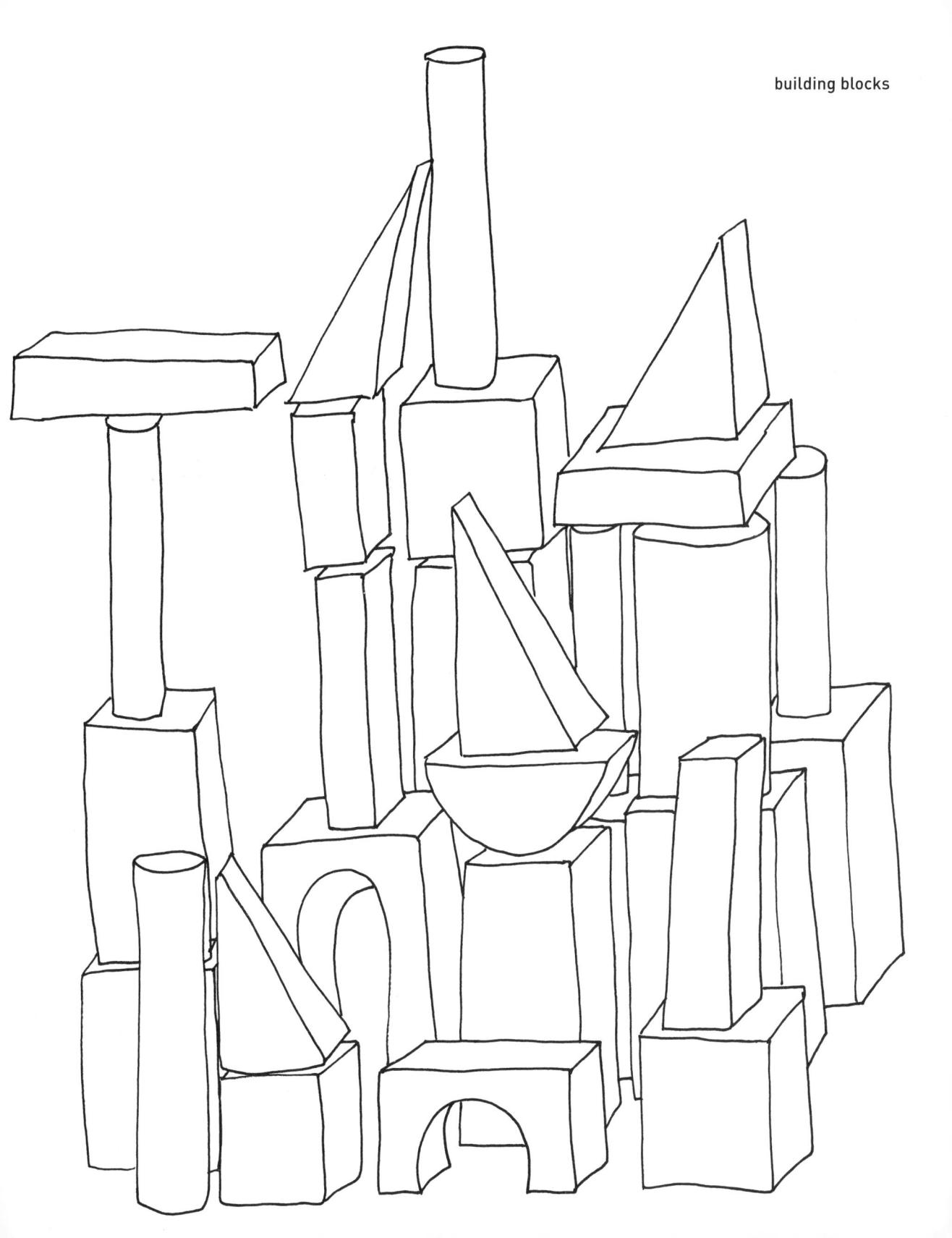

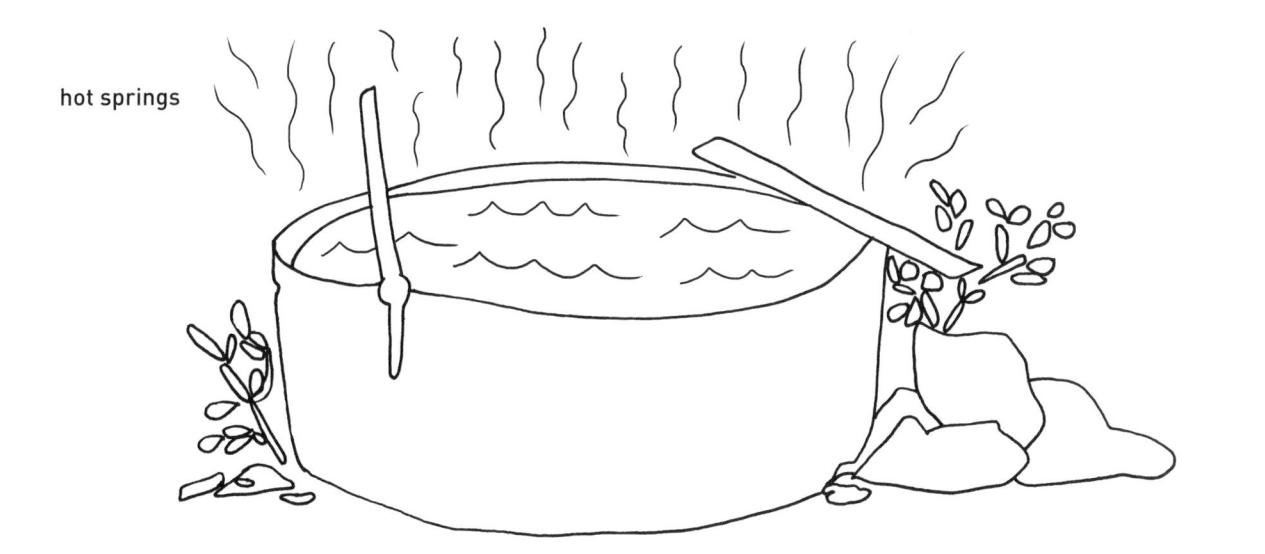

steak and potatoes

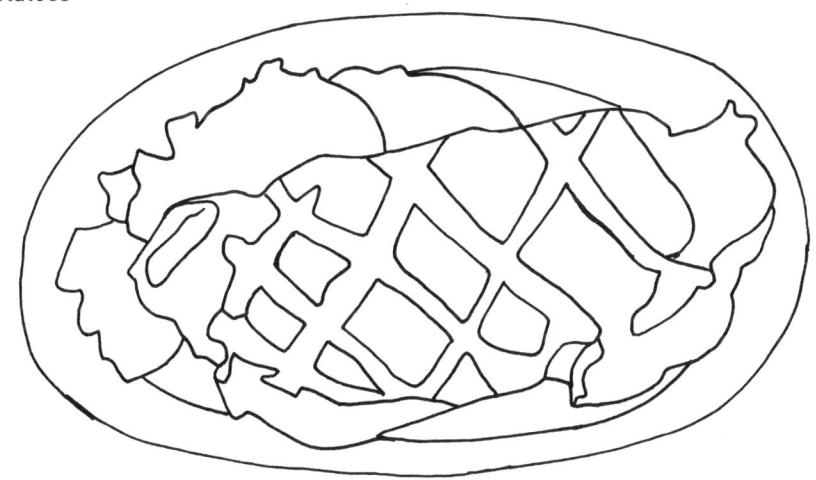

spools of thread

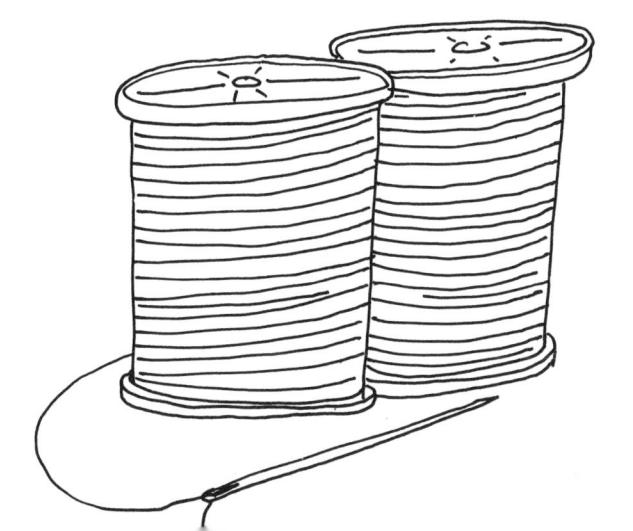

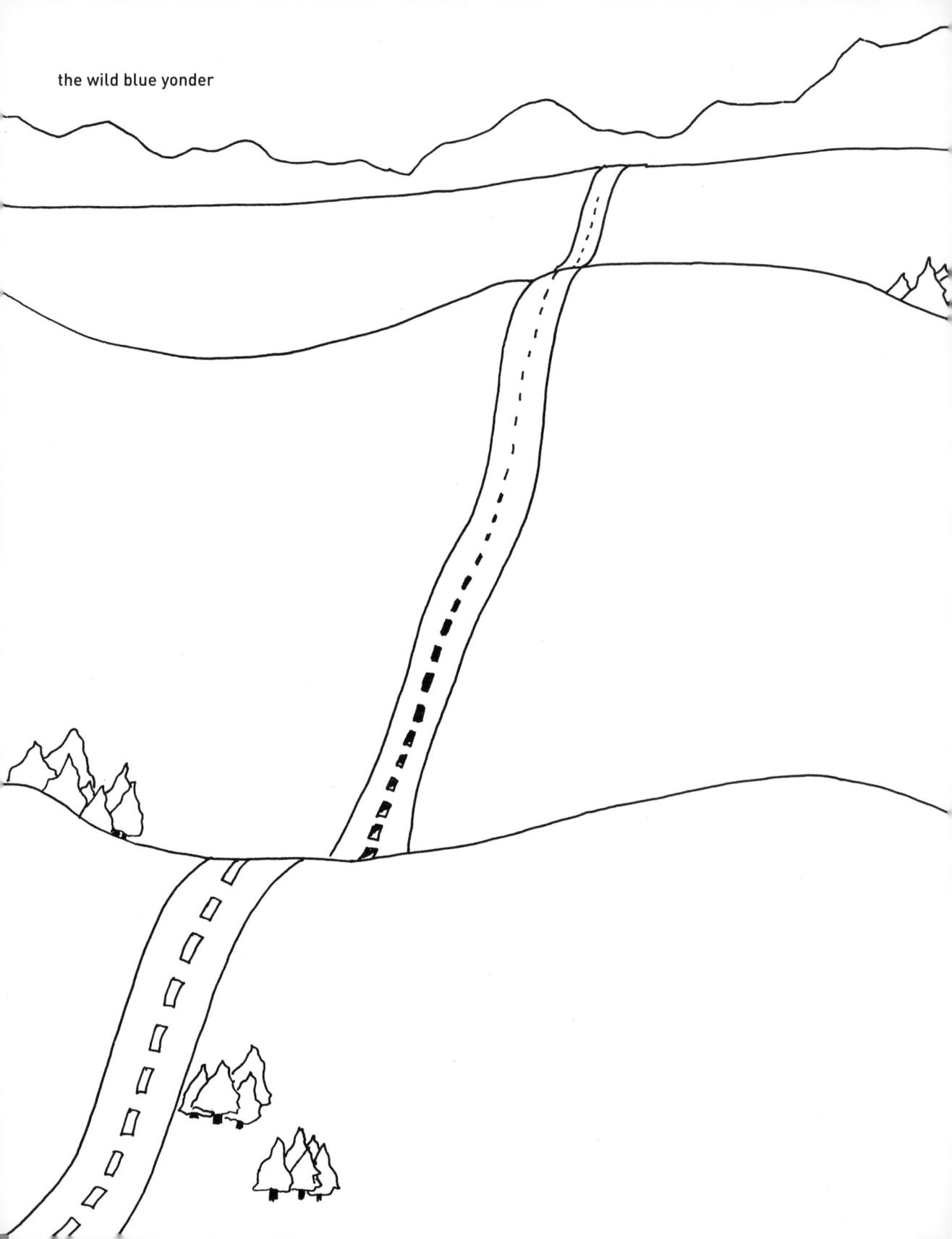

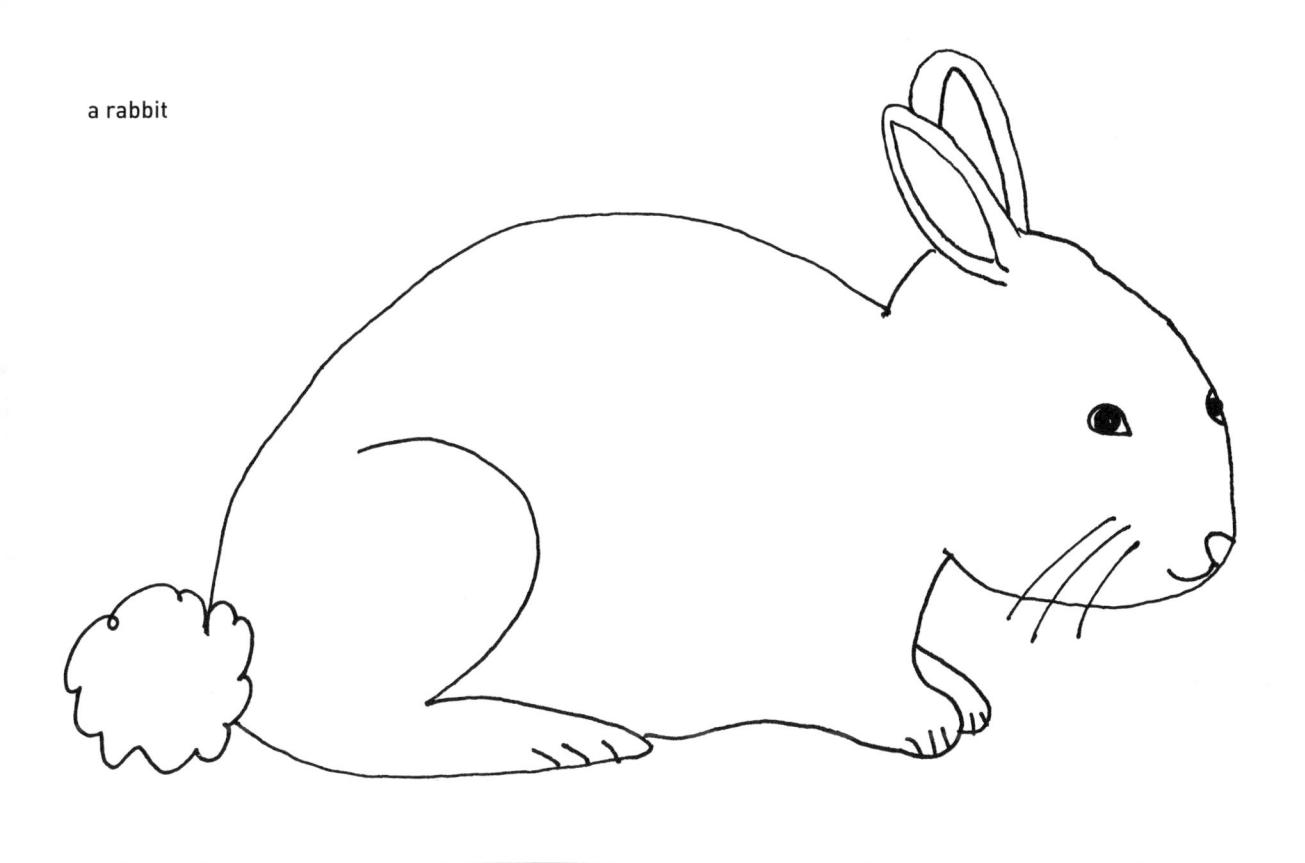

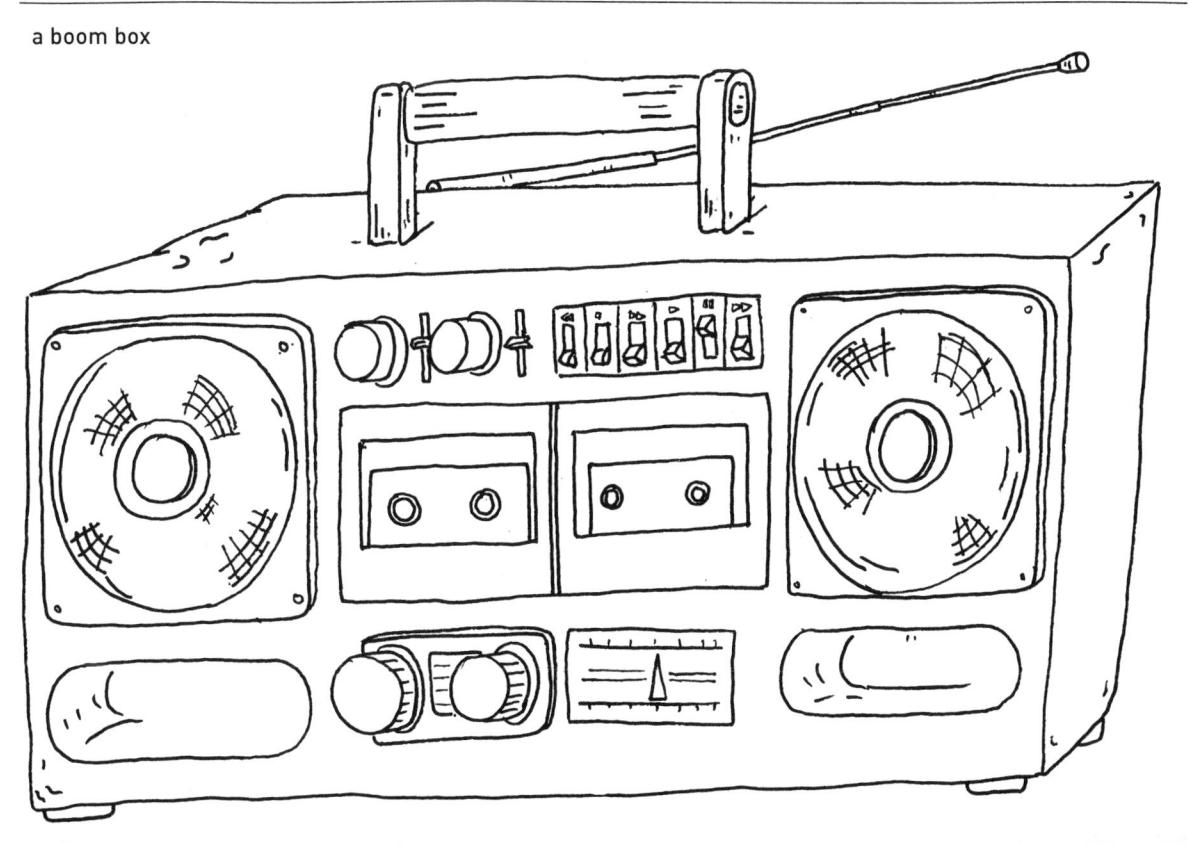

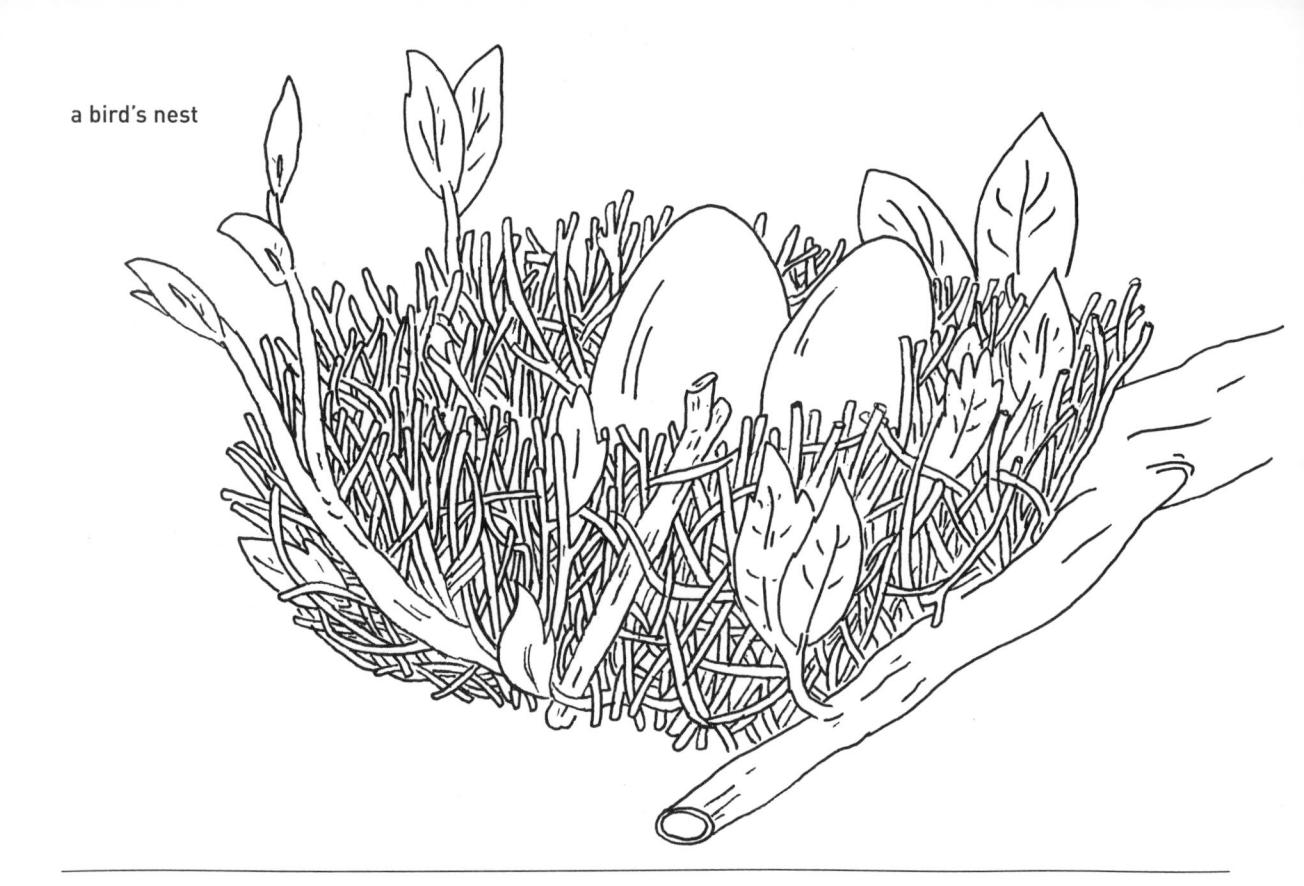

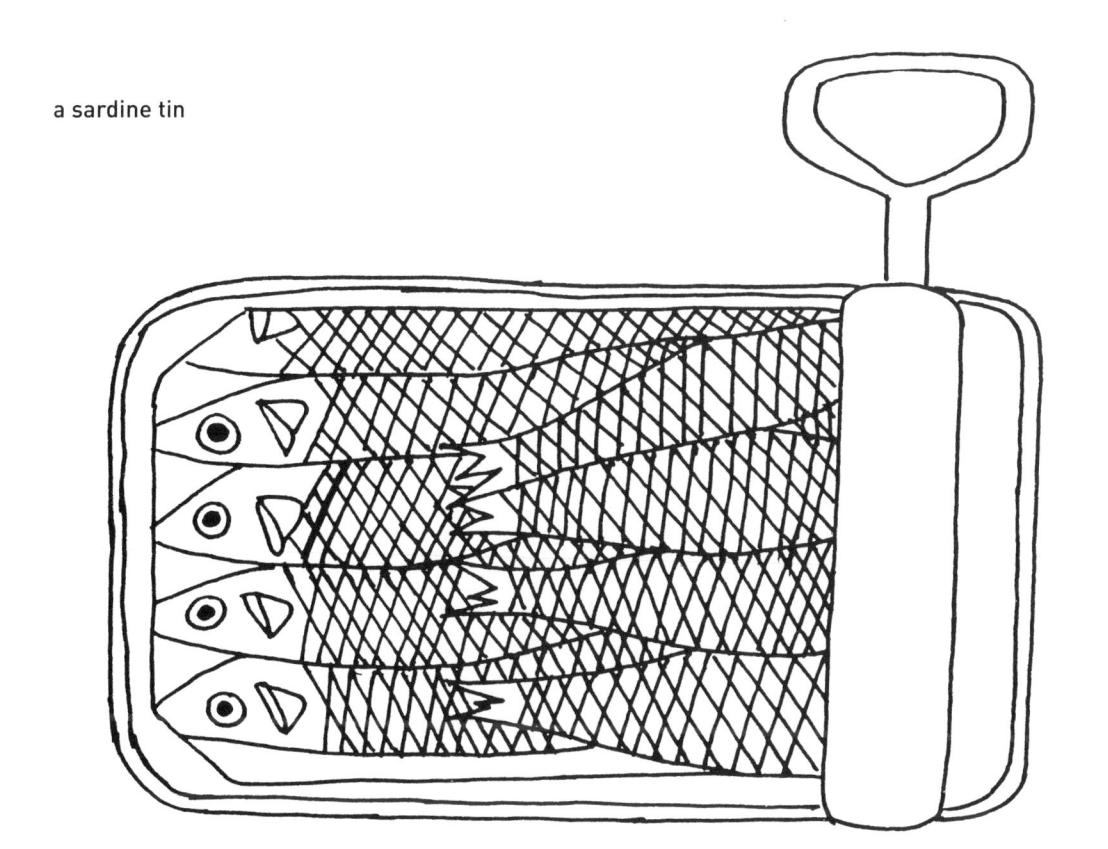

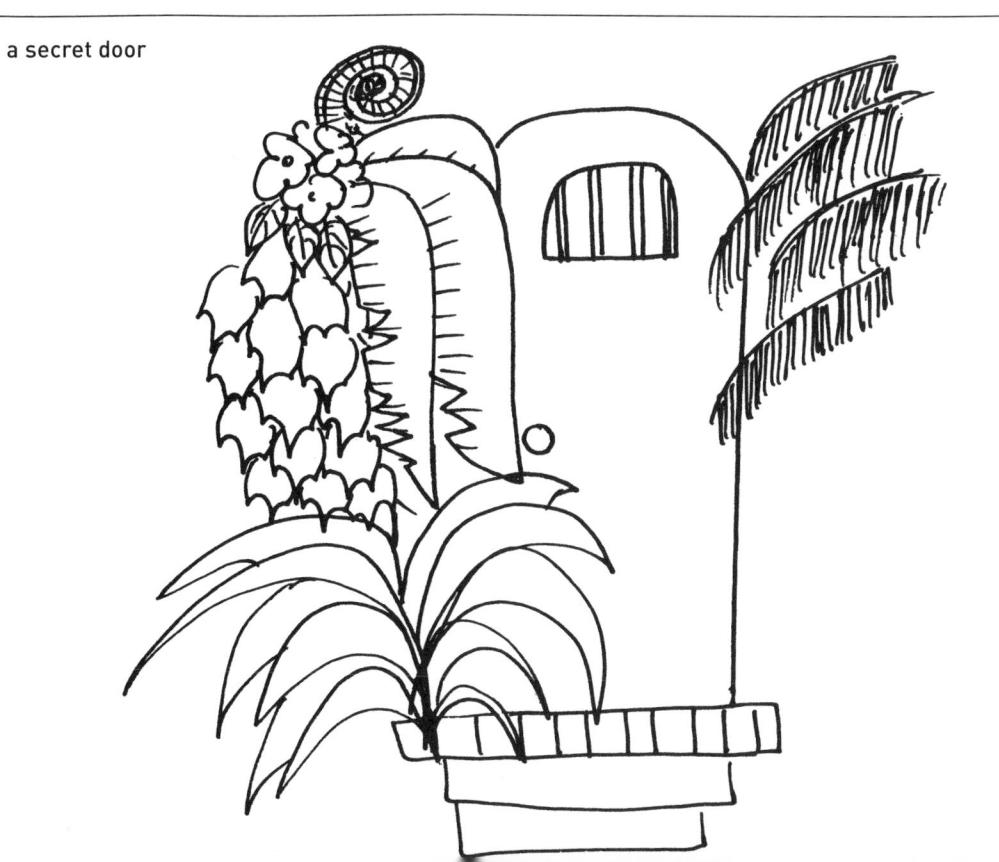

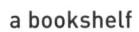

dumplings

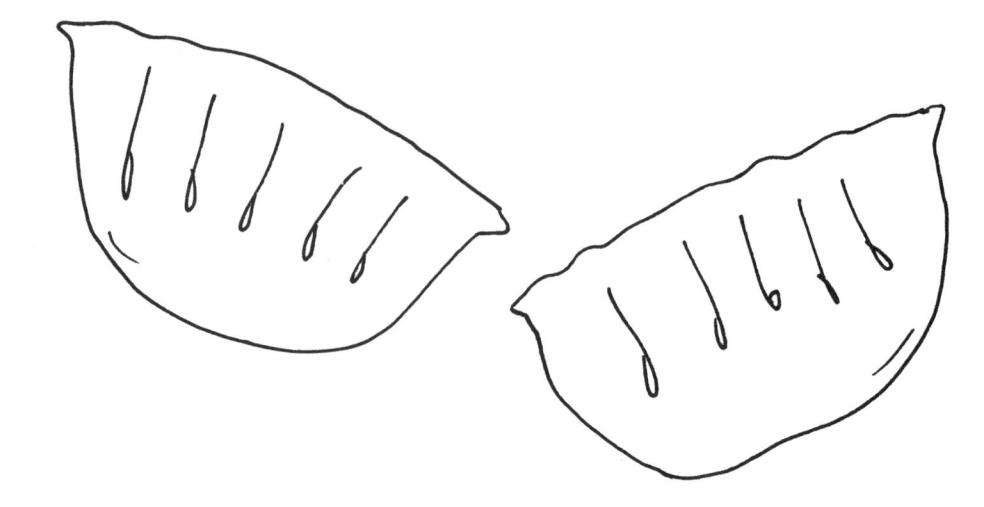

a bowl of pudding

a turntable

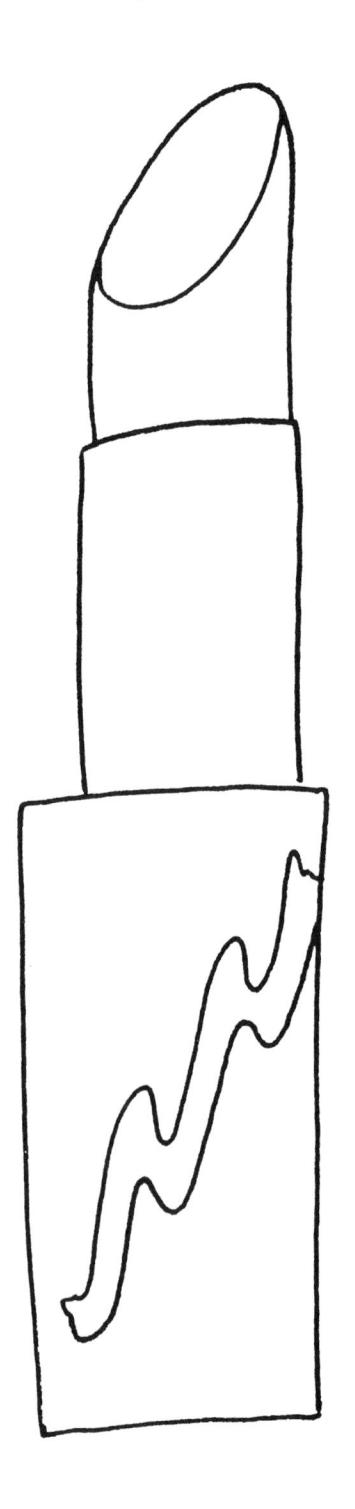

a frying pan

potato salad

a teacup

a palm tree

the periodic table

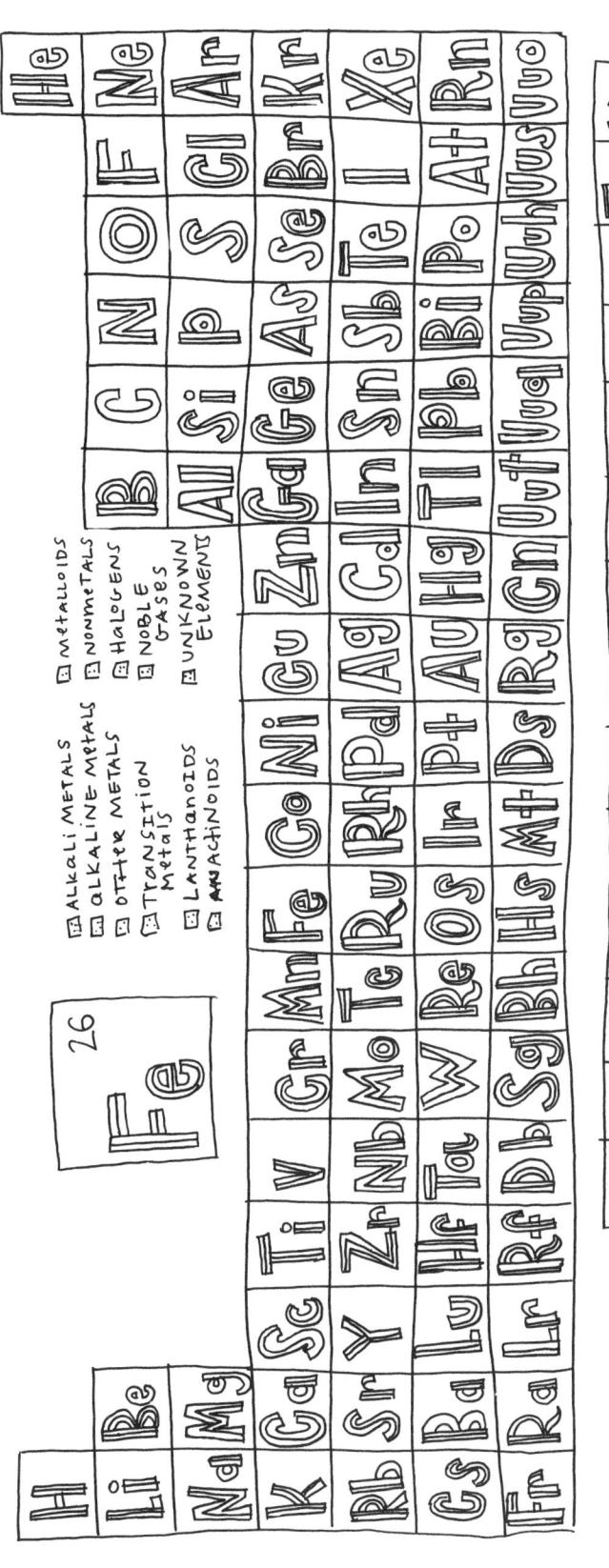

a brain

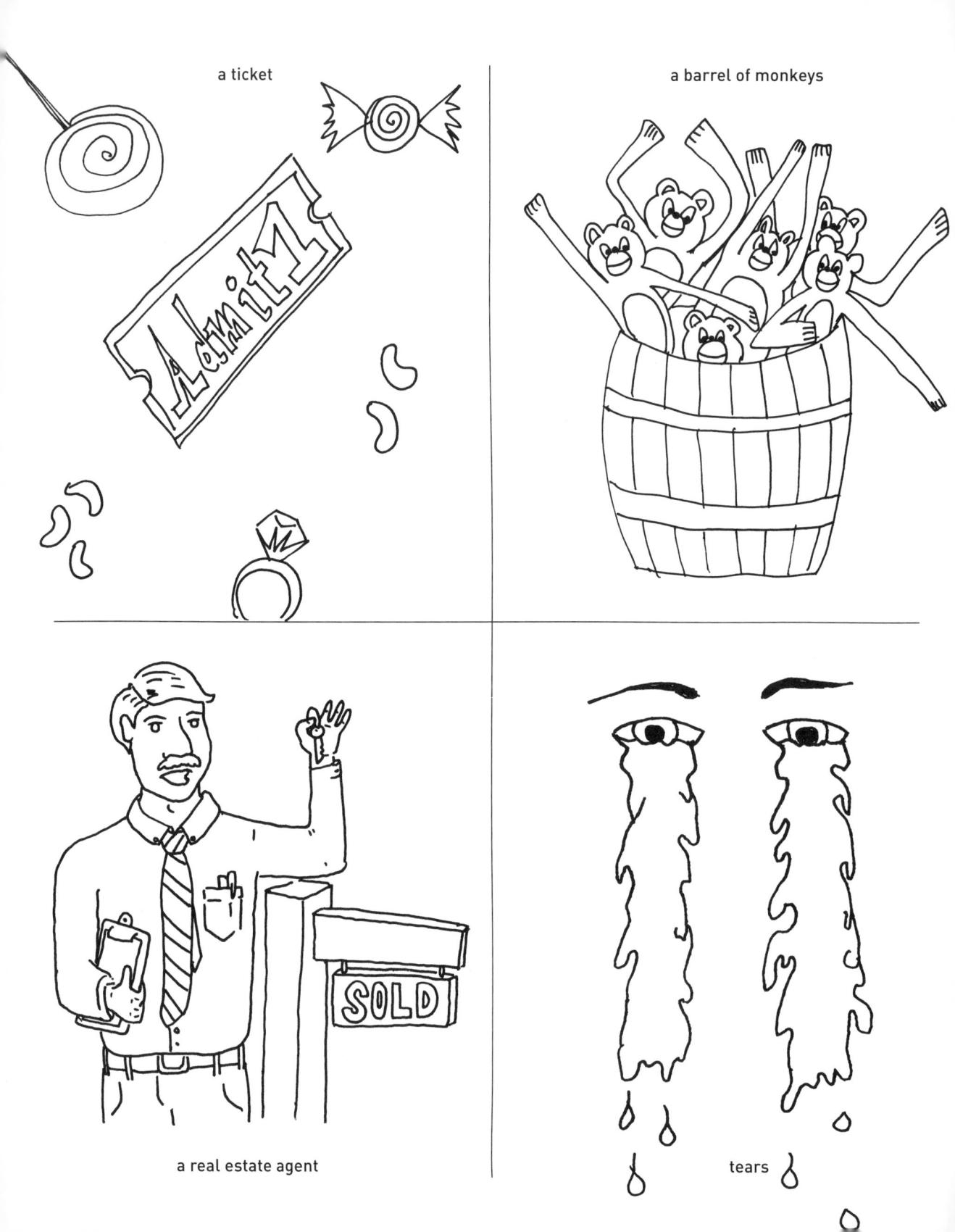

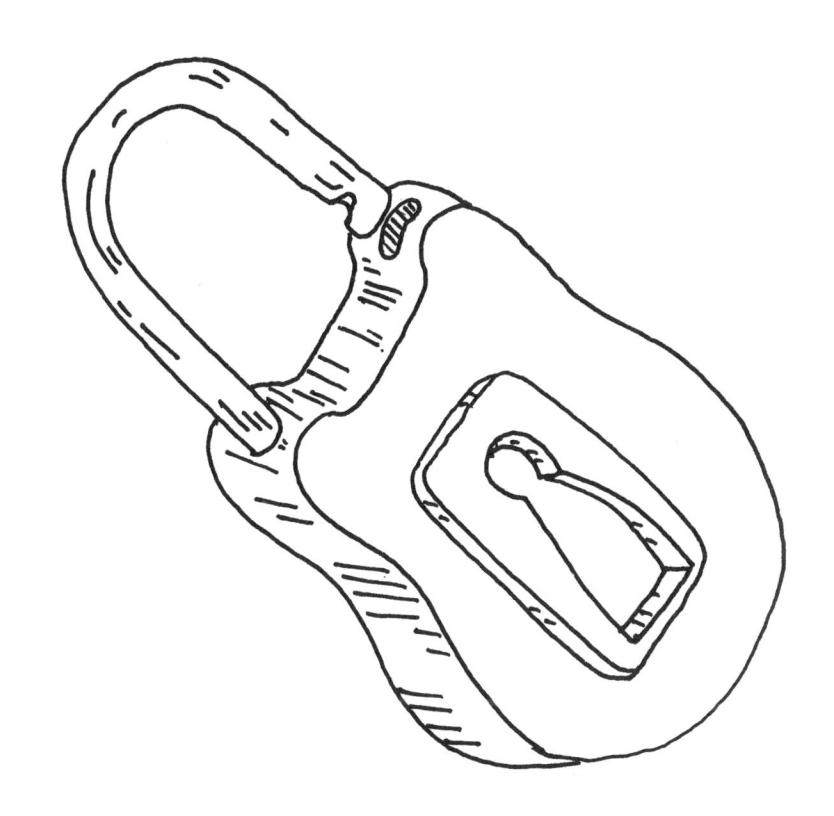

a tongue

peanut butter

a cranky old man

roller skates

a pillow

a string of DNA

a stick of gum

a ballpoint pen

a cornucopia

a cabbage patch

an inner tube

an elephant

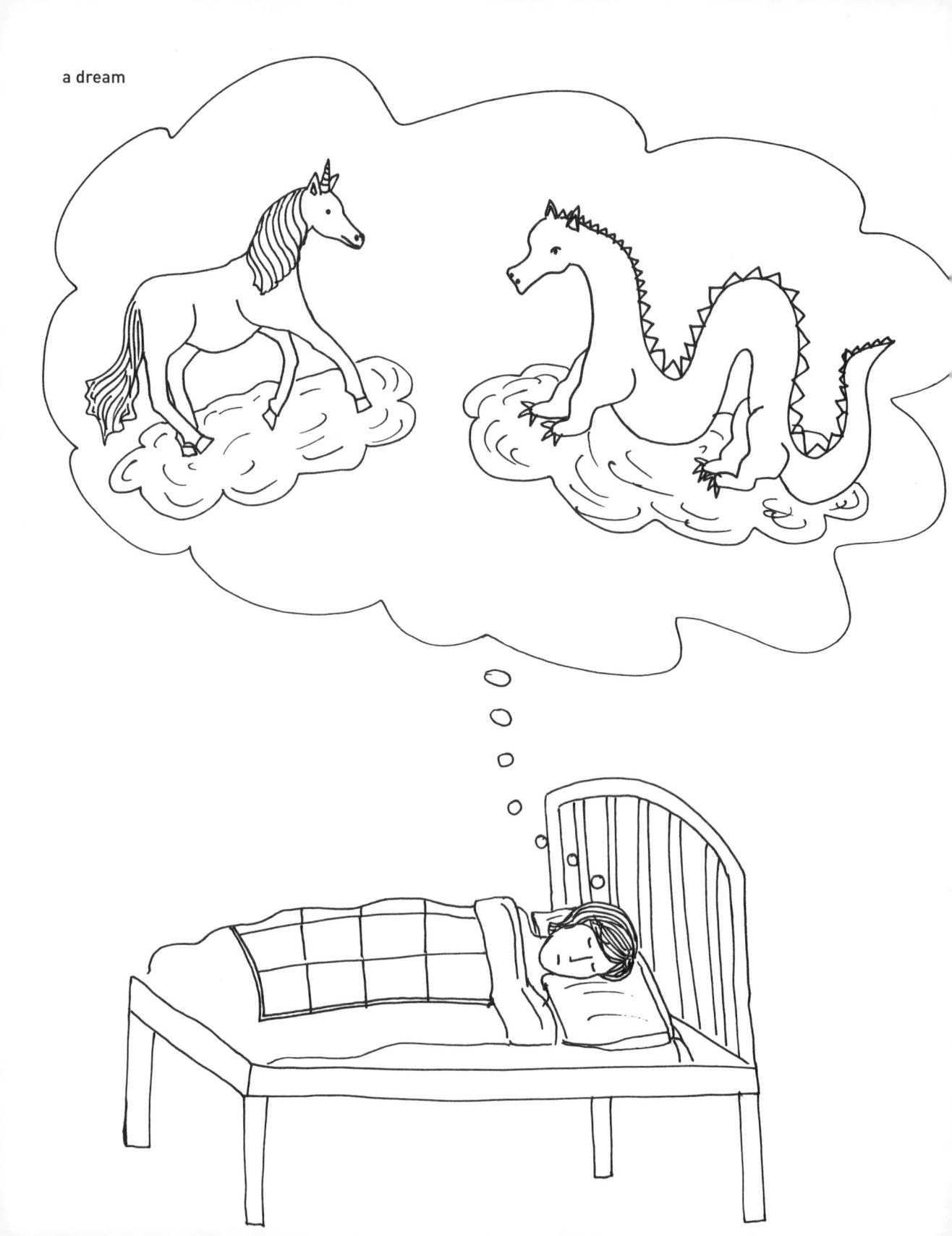

WELCOME TO NO-DESSERT LAND!

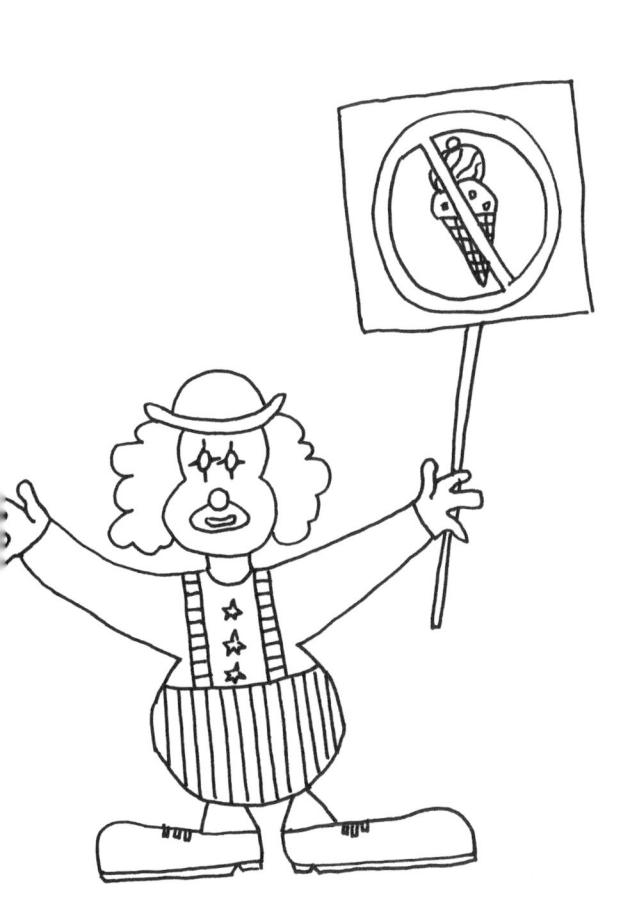

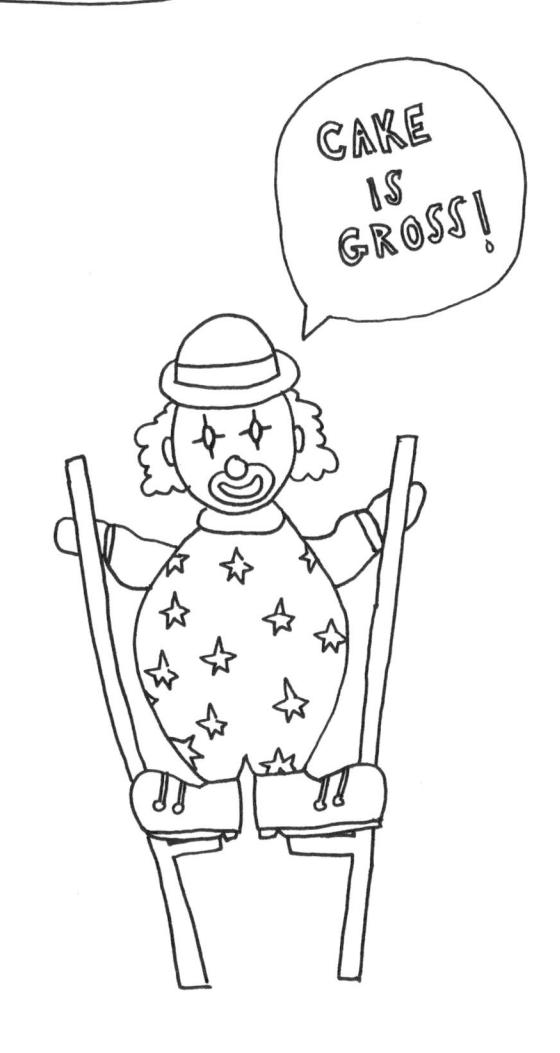

a tea bag

tiny ballerinas

a porcupine

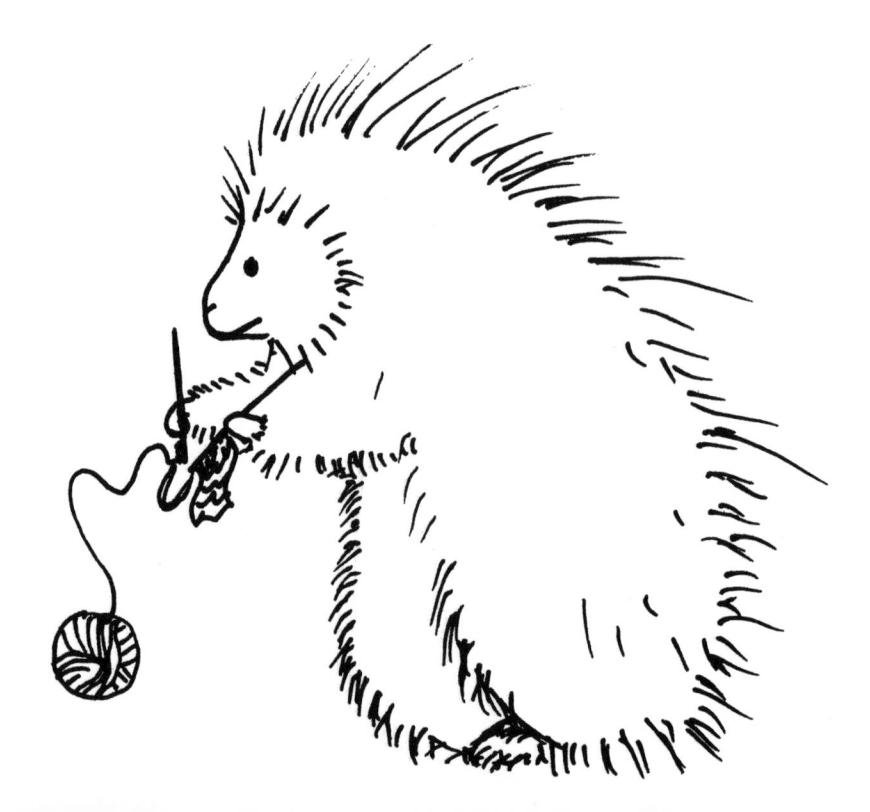

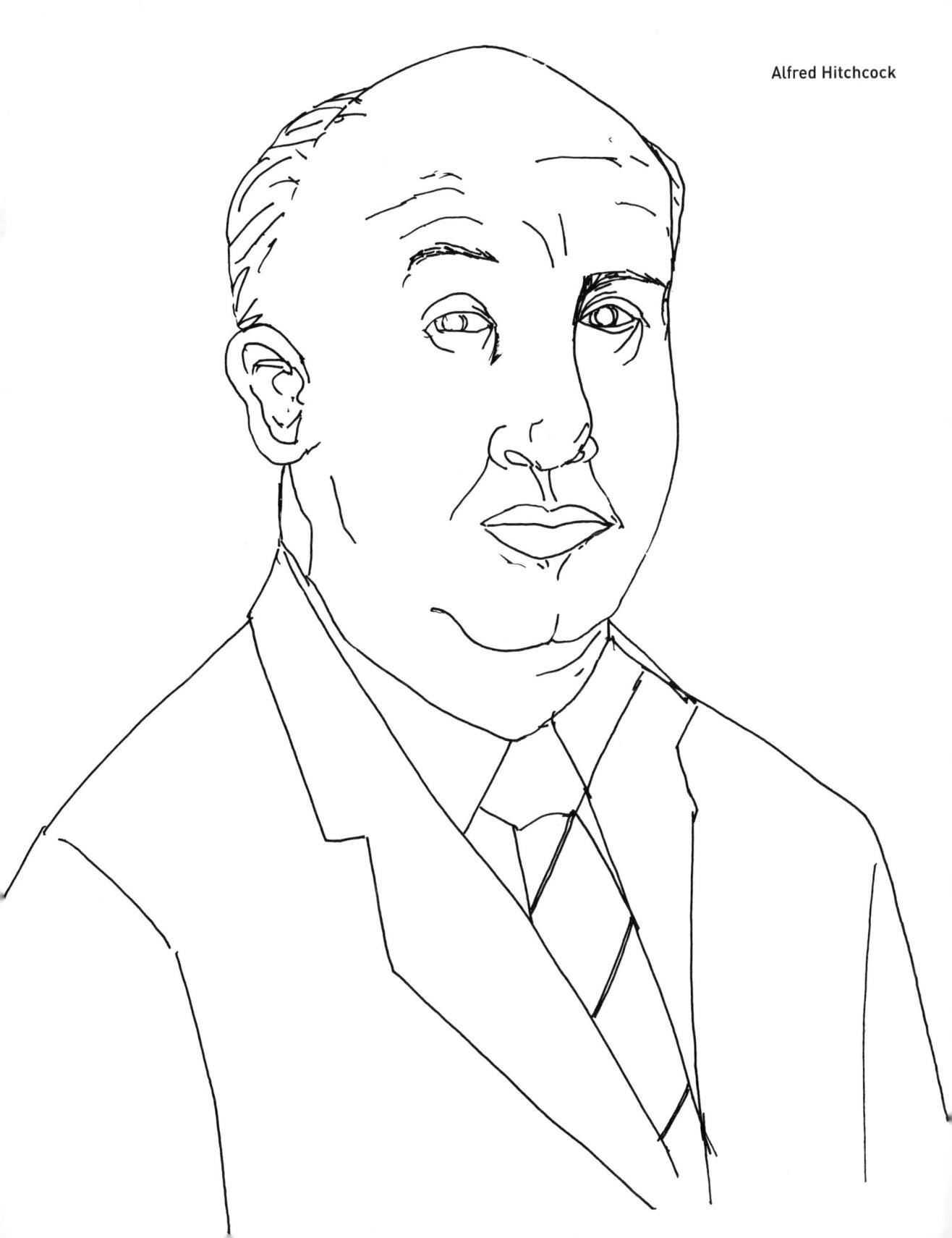

a steak

a pirate flag

a loading crane

a tube of toothpaste

a turnip

a trailer

S Mary

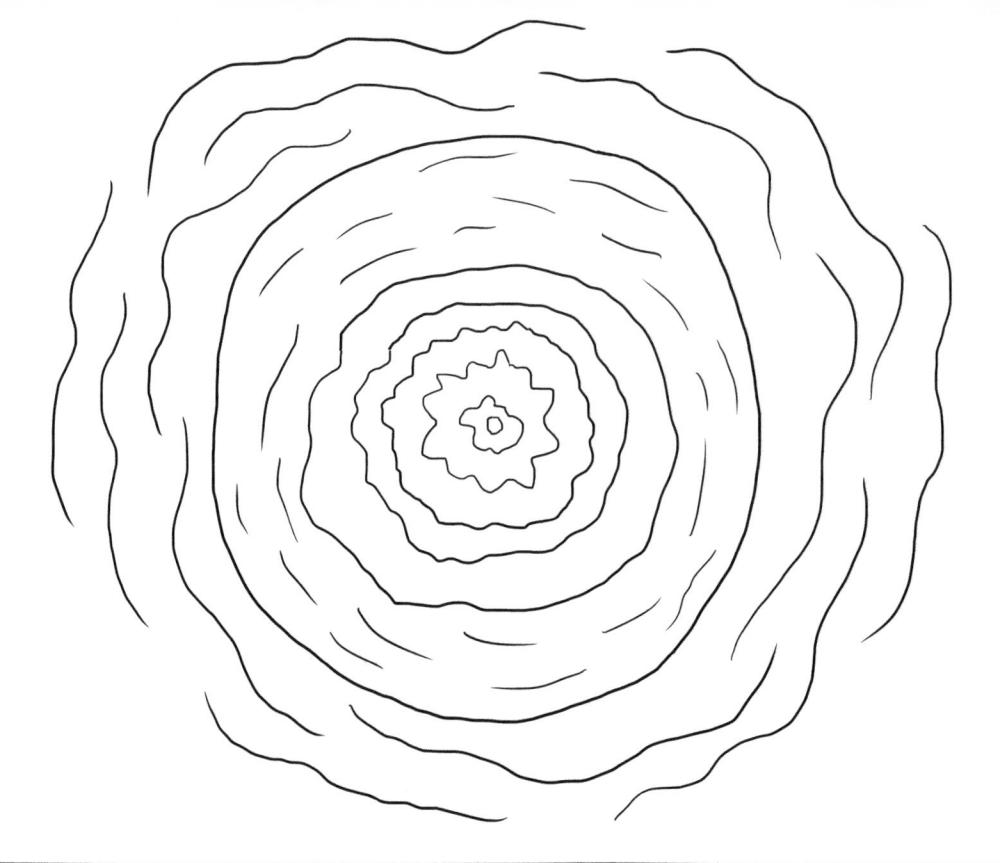

a long-playing record

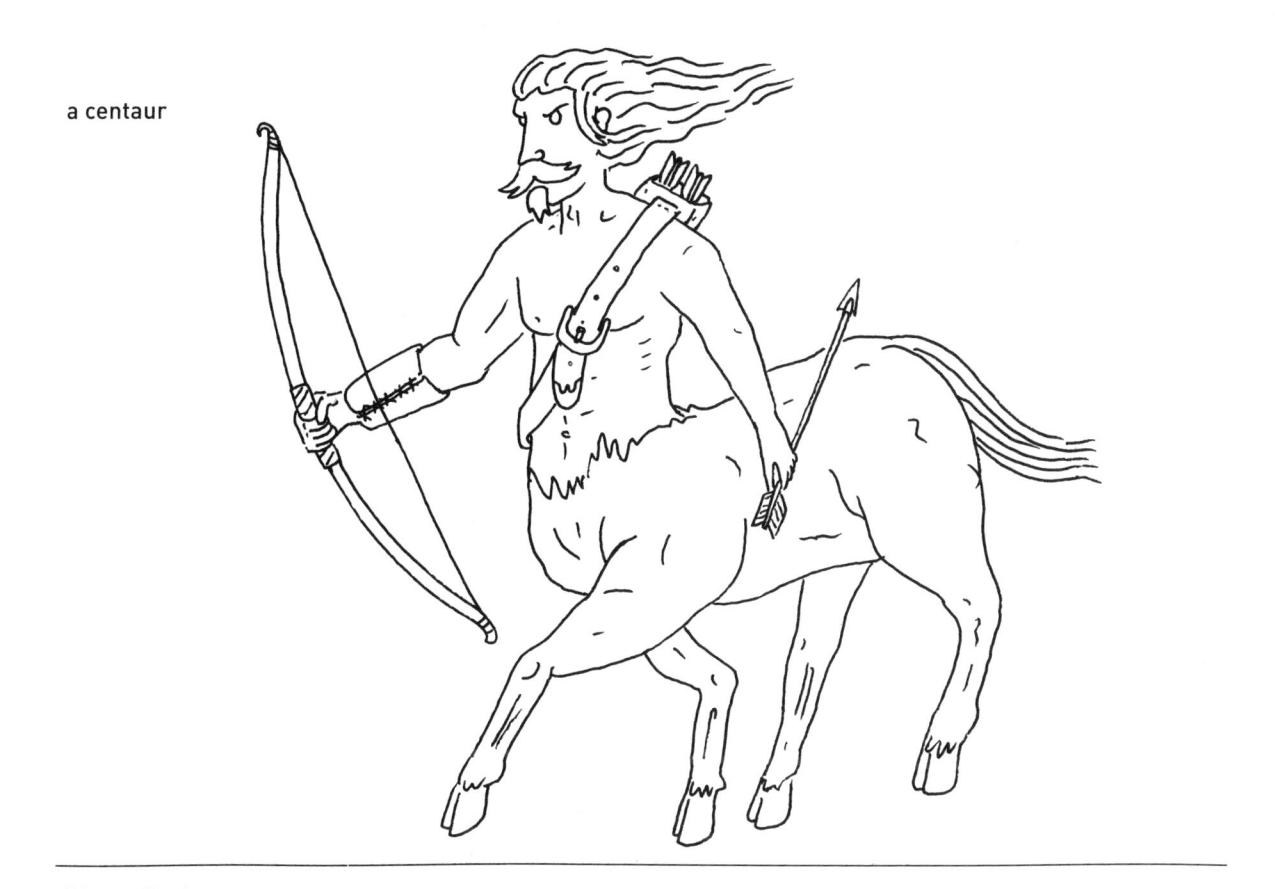

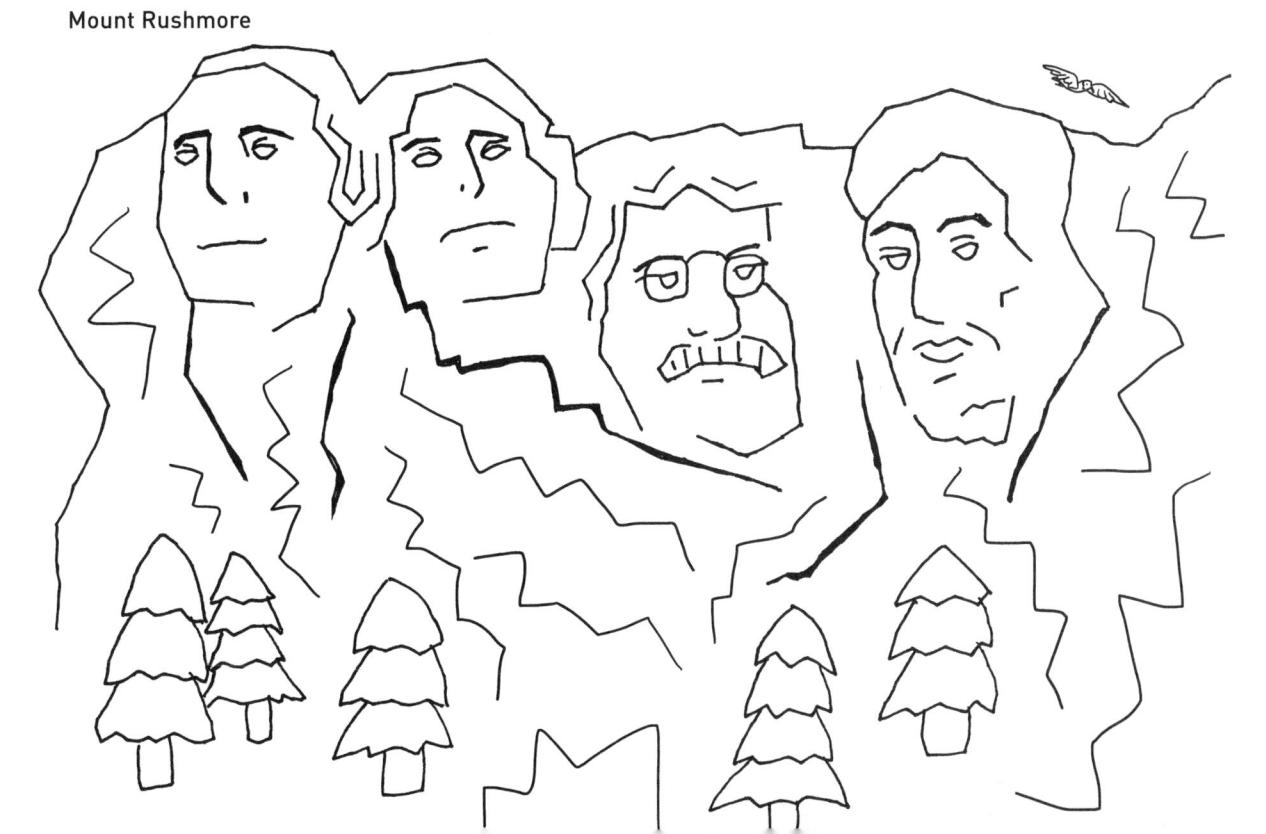

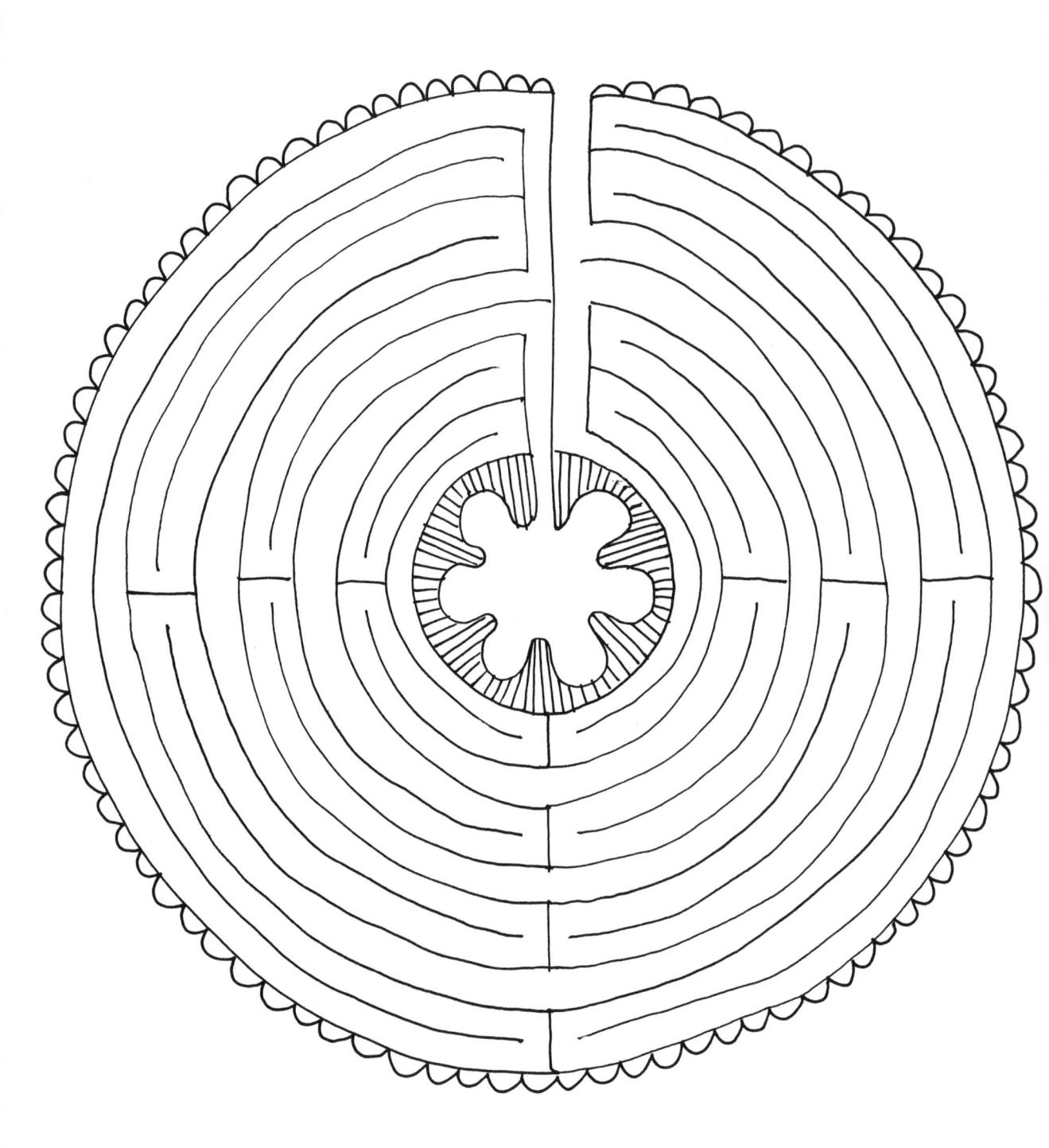

your pinky finger

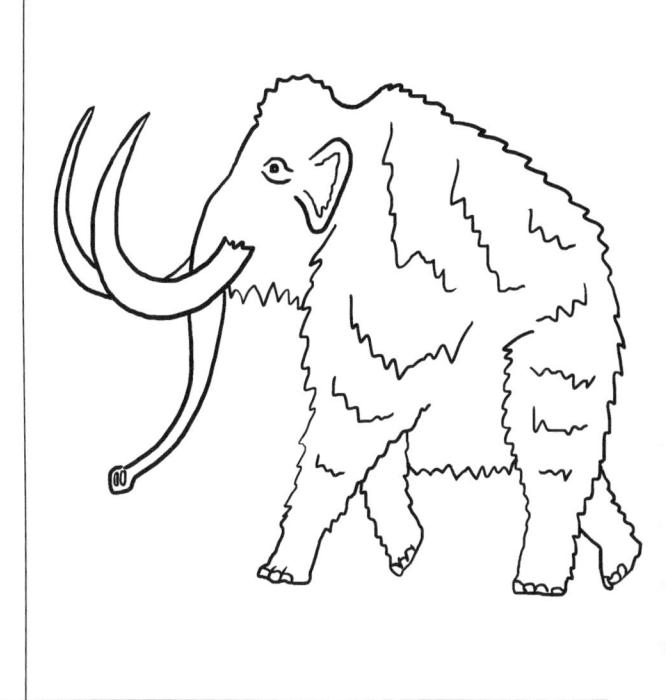

a boss

an ashtray

mismatched earrings

freckles

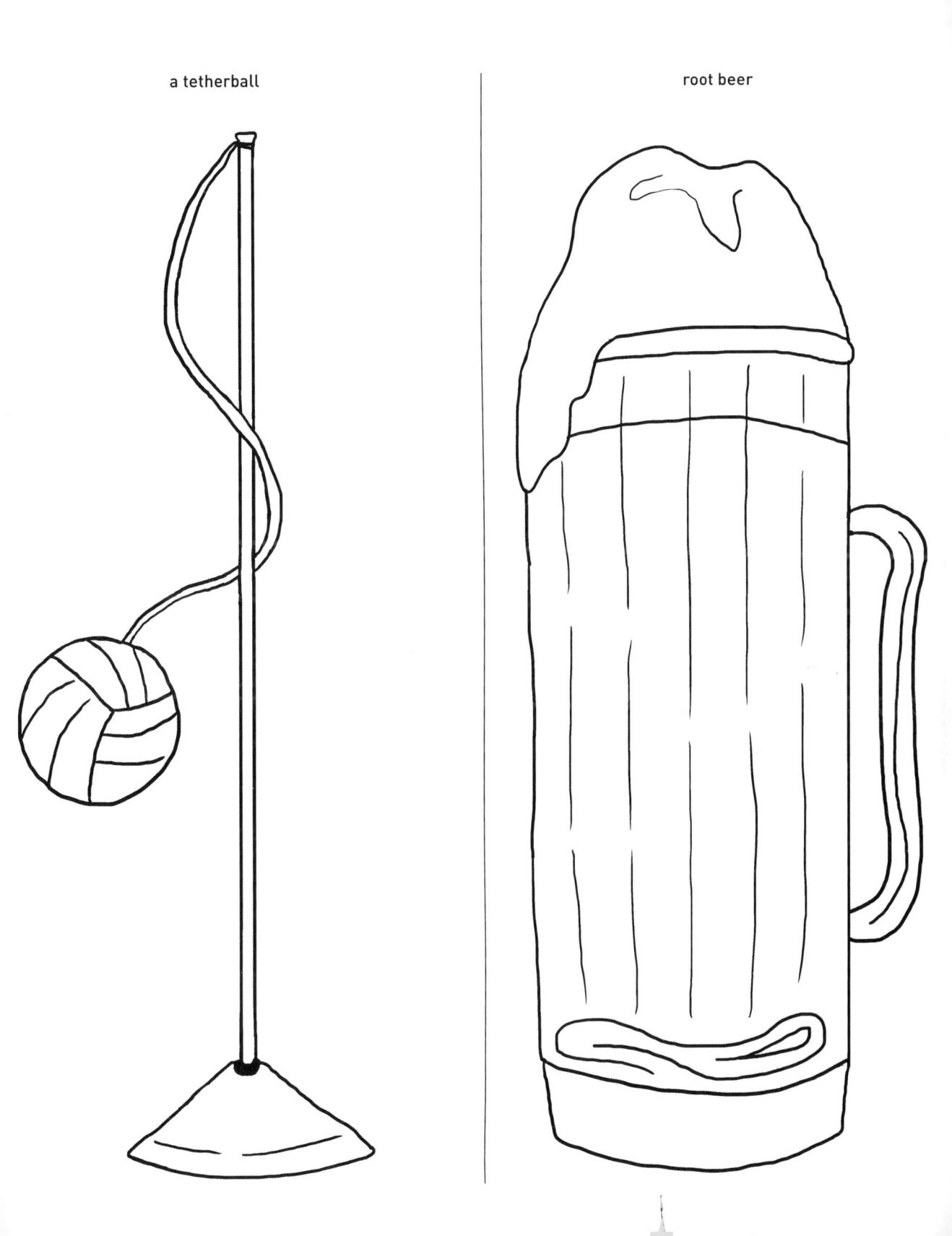

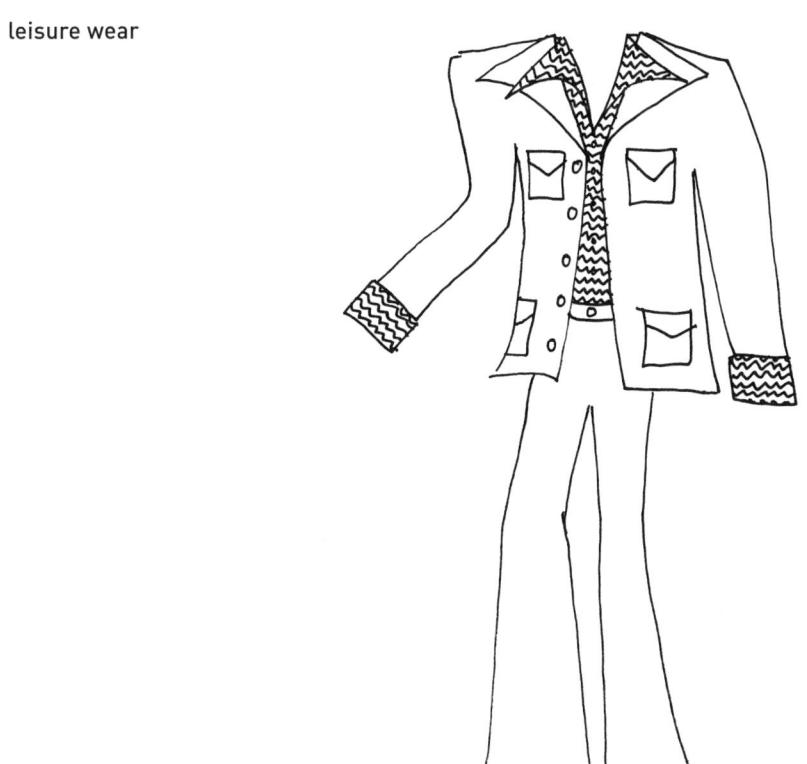

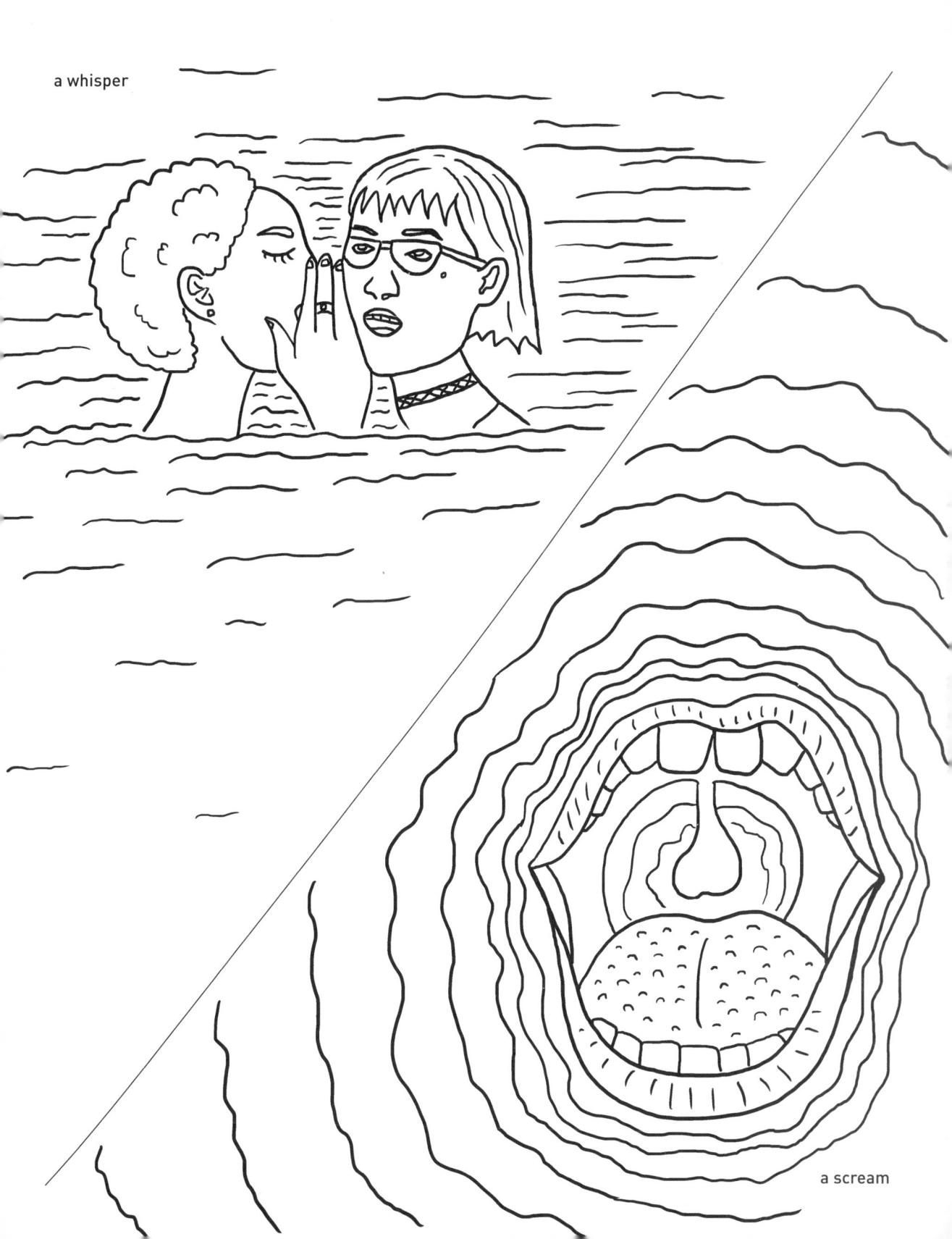

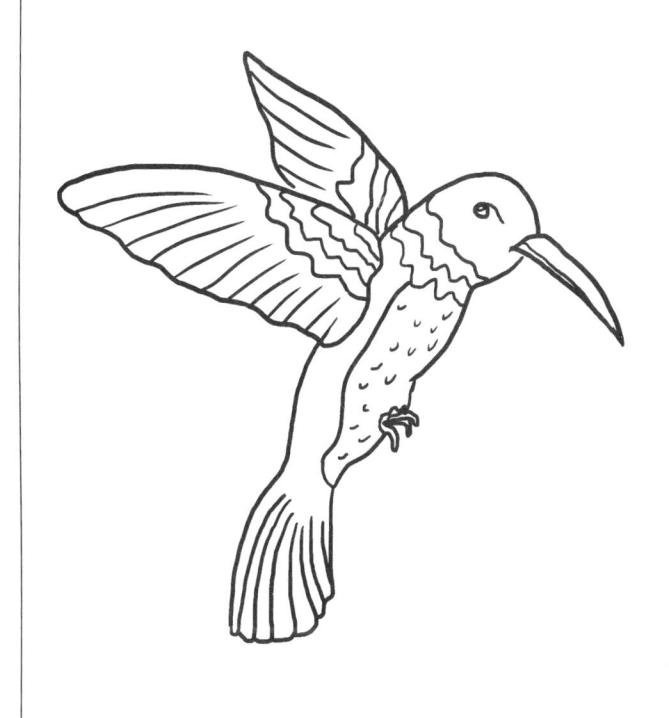

a condiment

a safety pin

lucky charms

a belt buckle

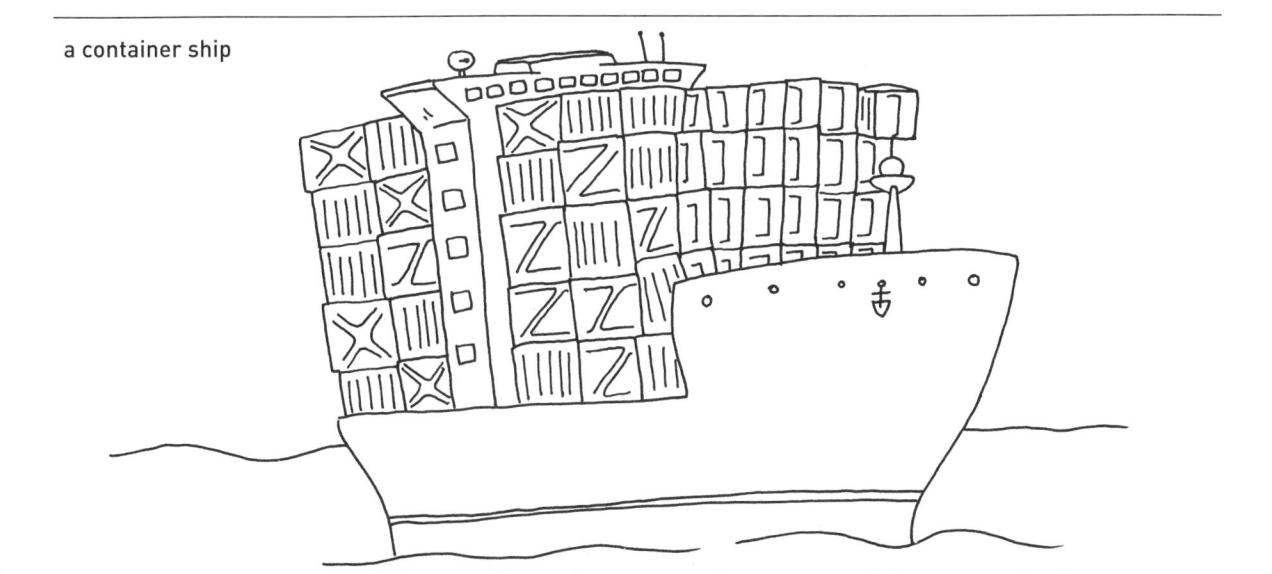

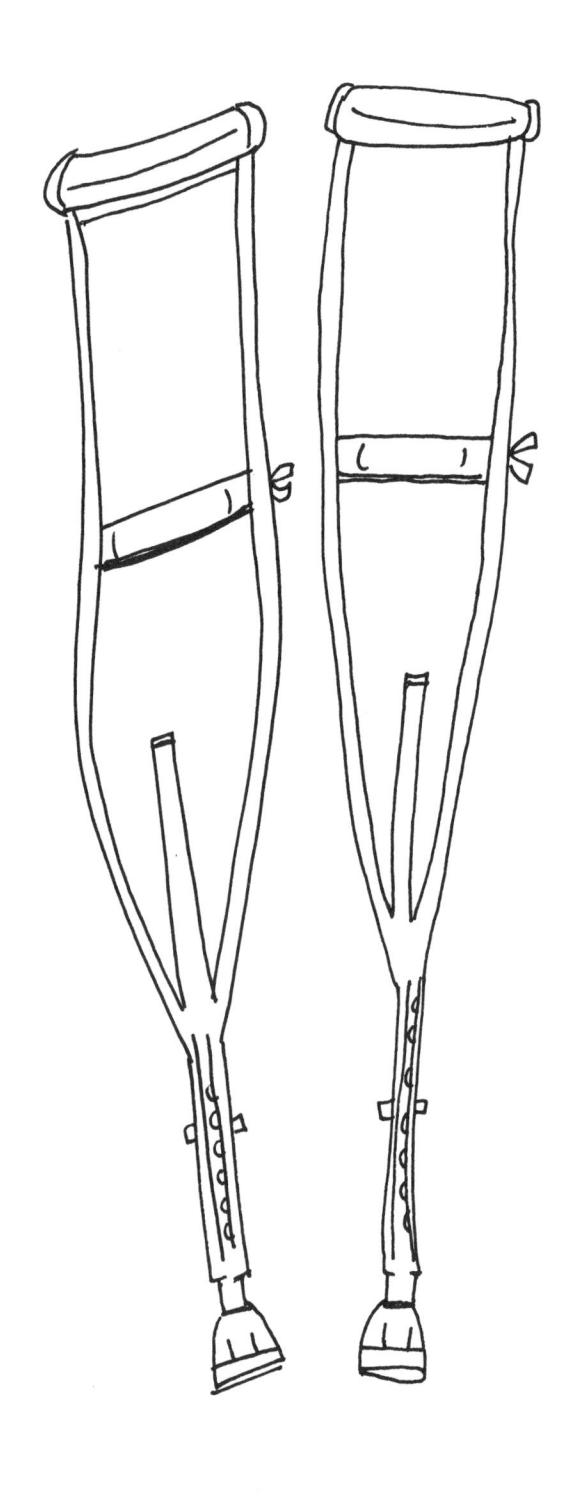

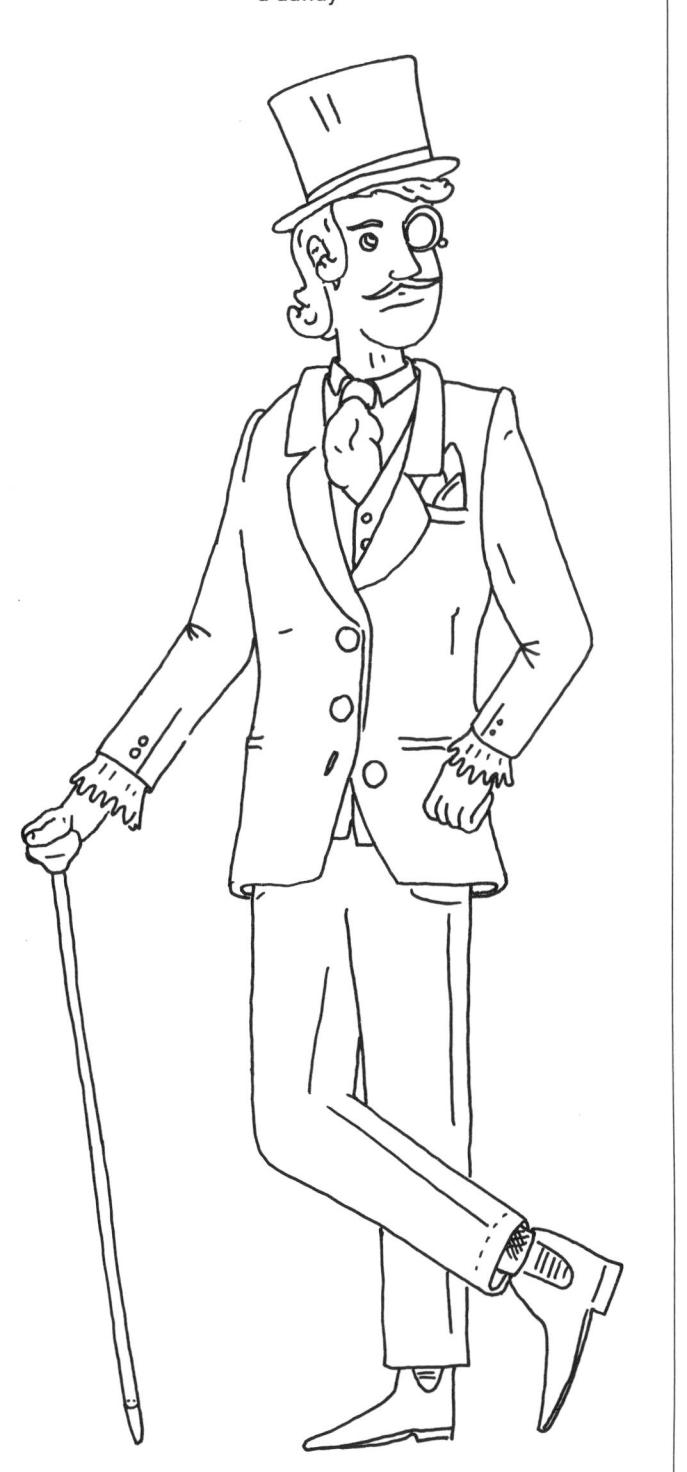

a seashell

a feathered hat

a pinecone

shrimp cocktail

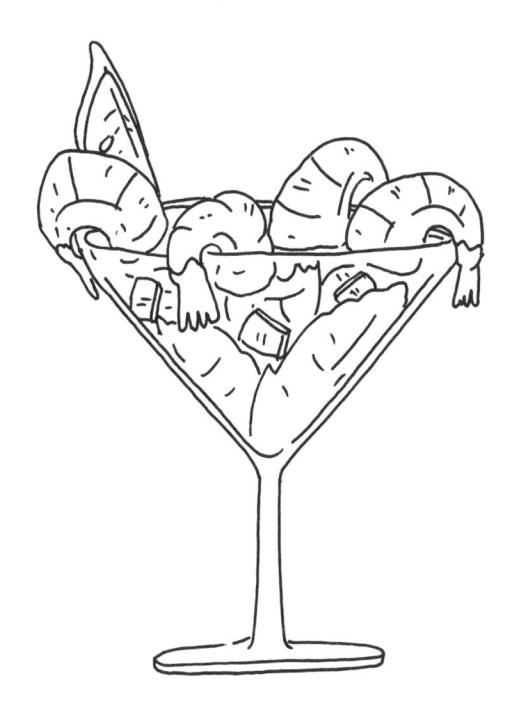

an eggbeater

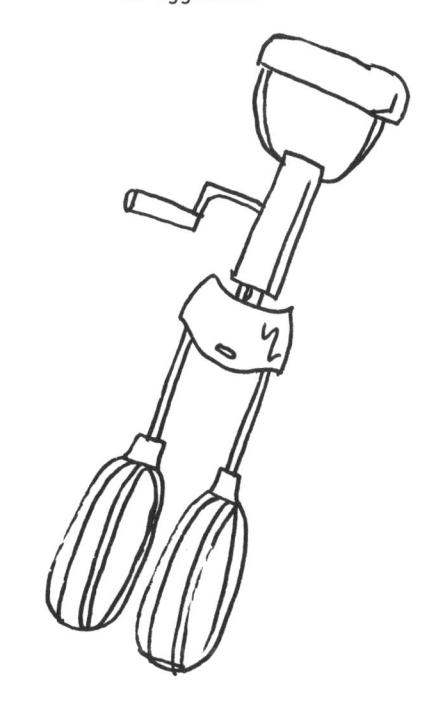

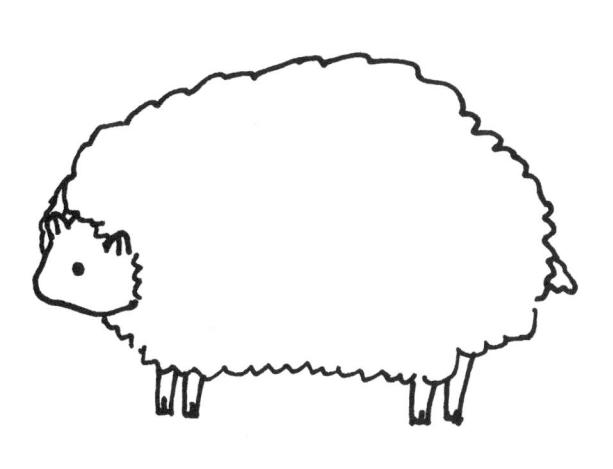

a sheep

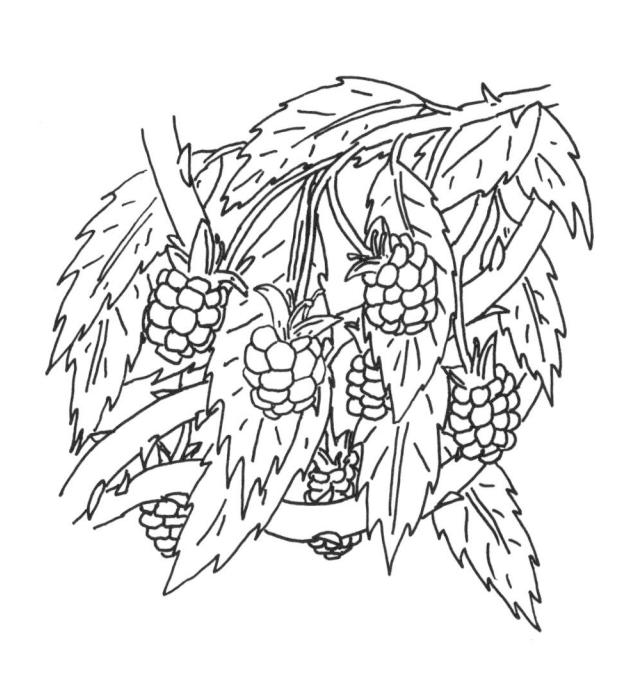

a blackberry bush

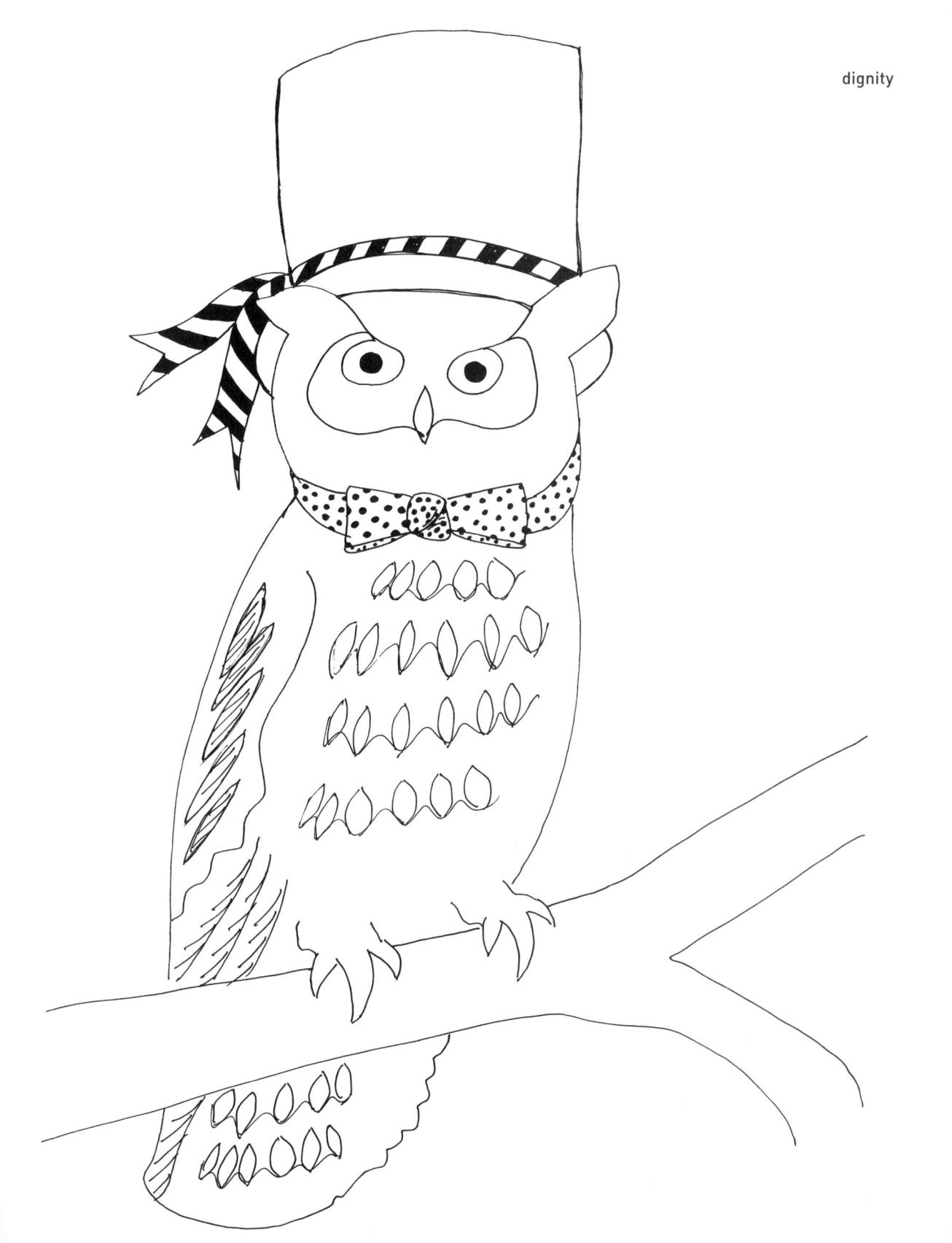

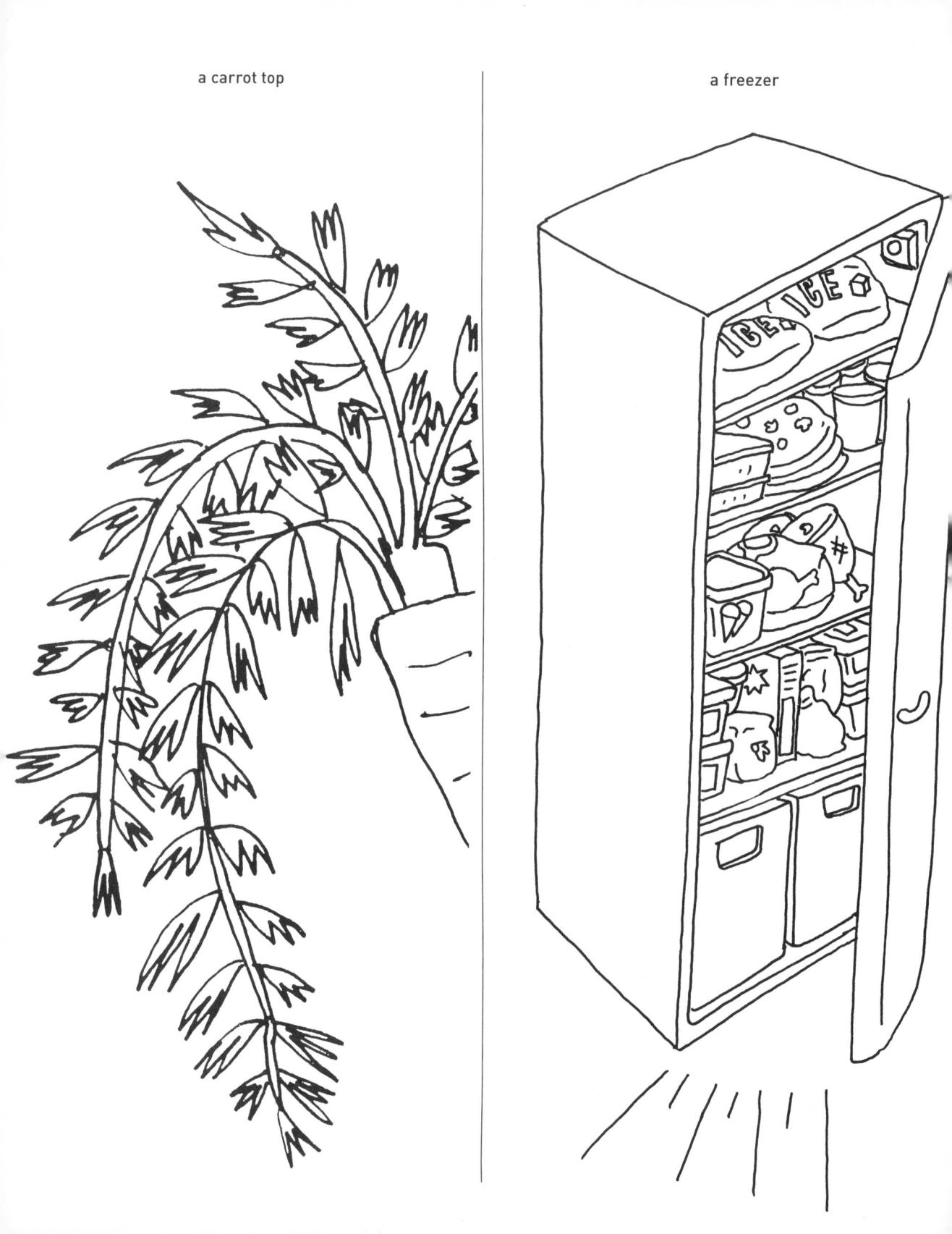

a pineapple upside-down cake

a goldfish

a recycling bin

a sweatband

a strawberry

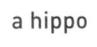

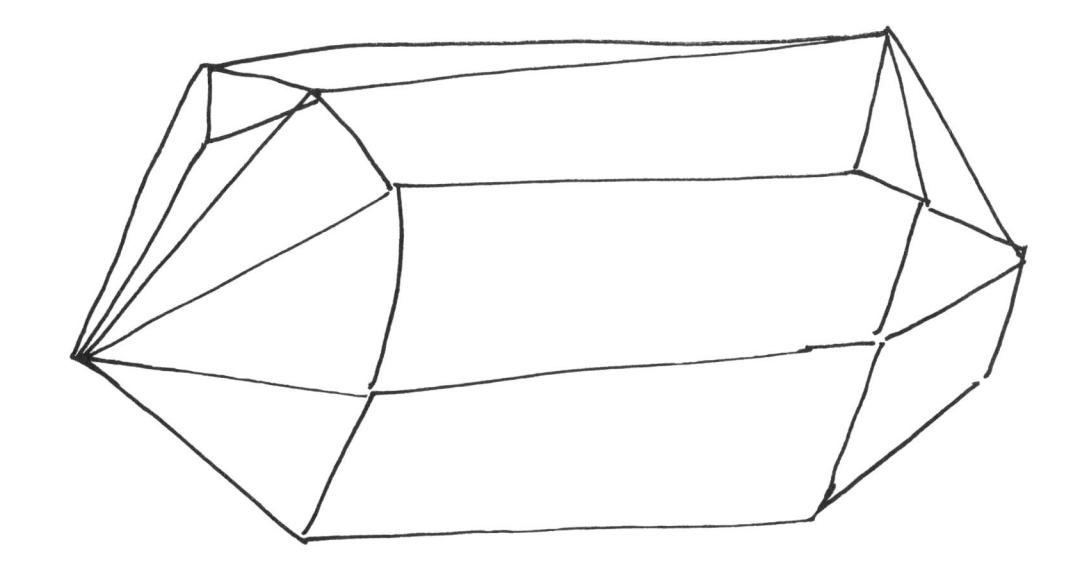

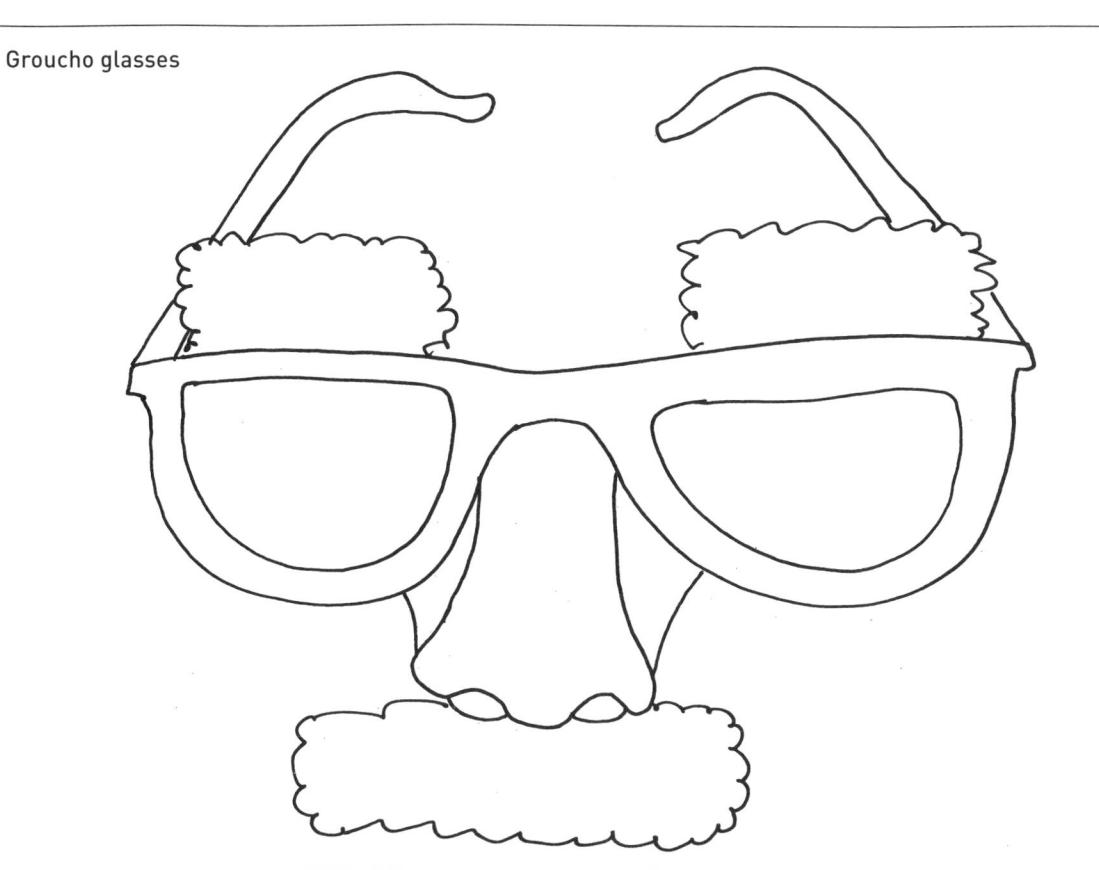

a tractor

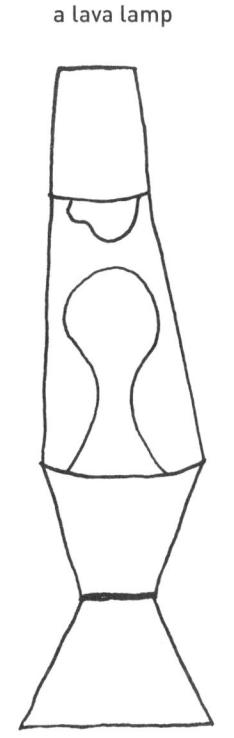

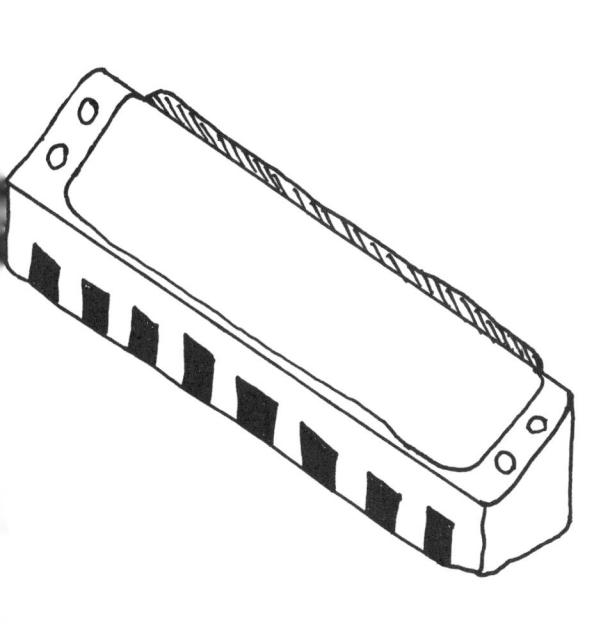

a harmonica

a ruler

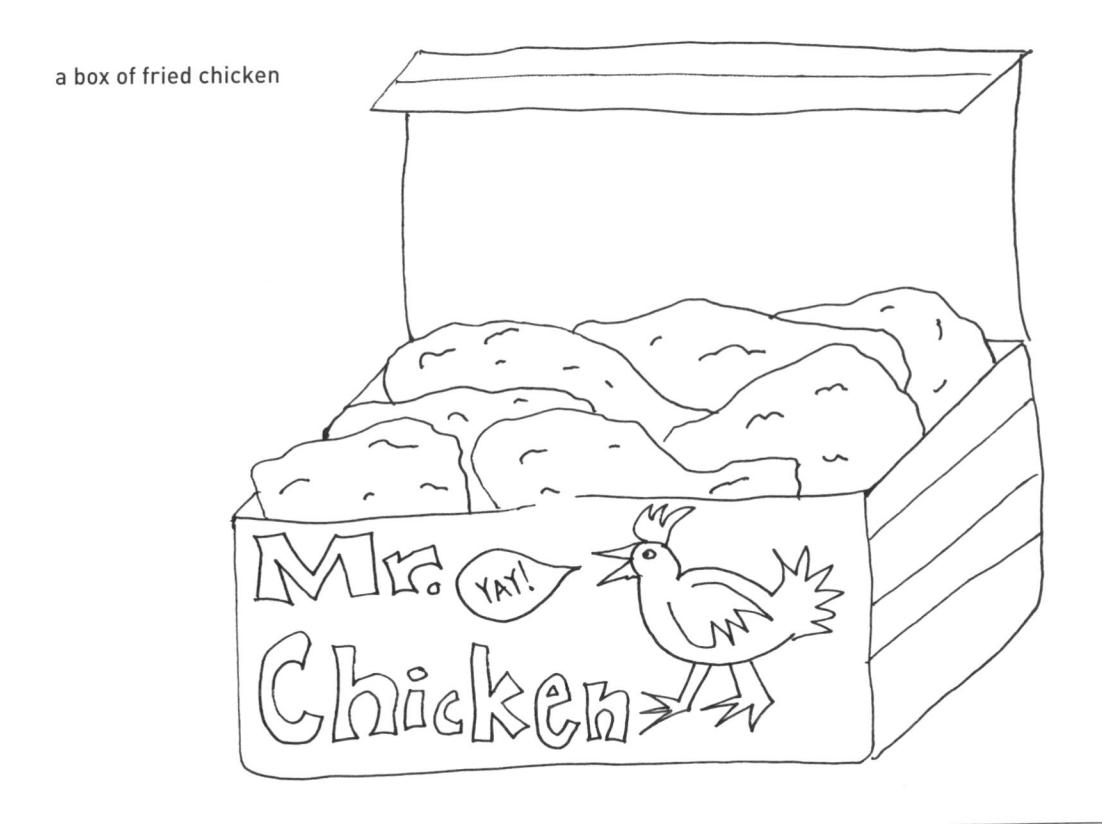

wise babies

a tarantula

a can of beans

a sand dollar

a bee

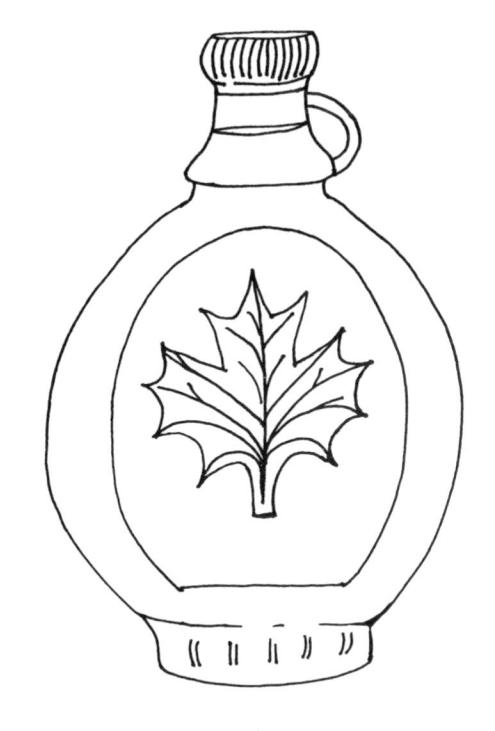

maple syrup

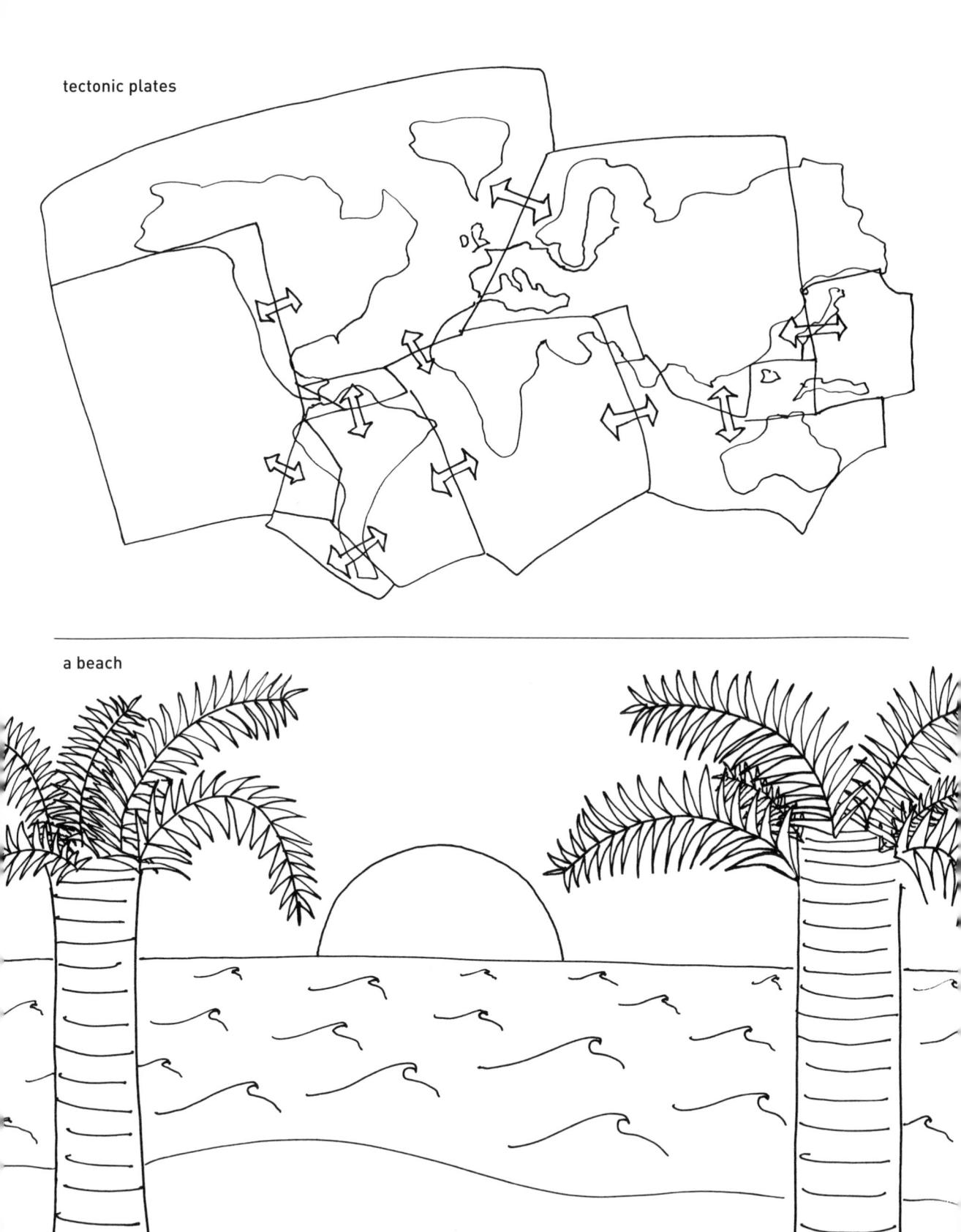

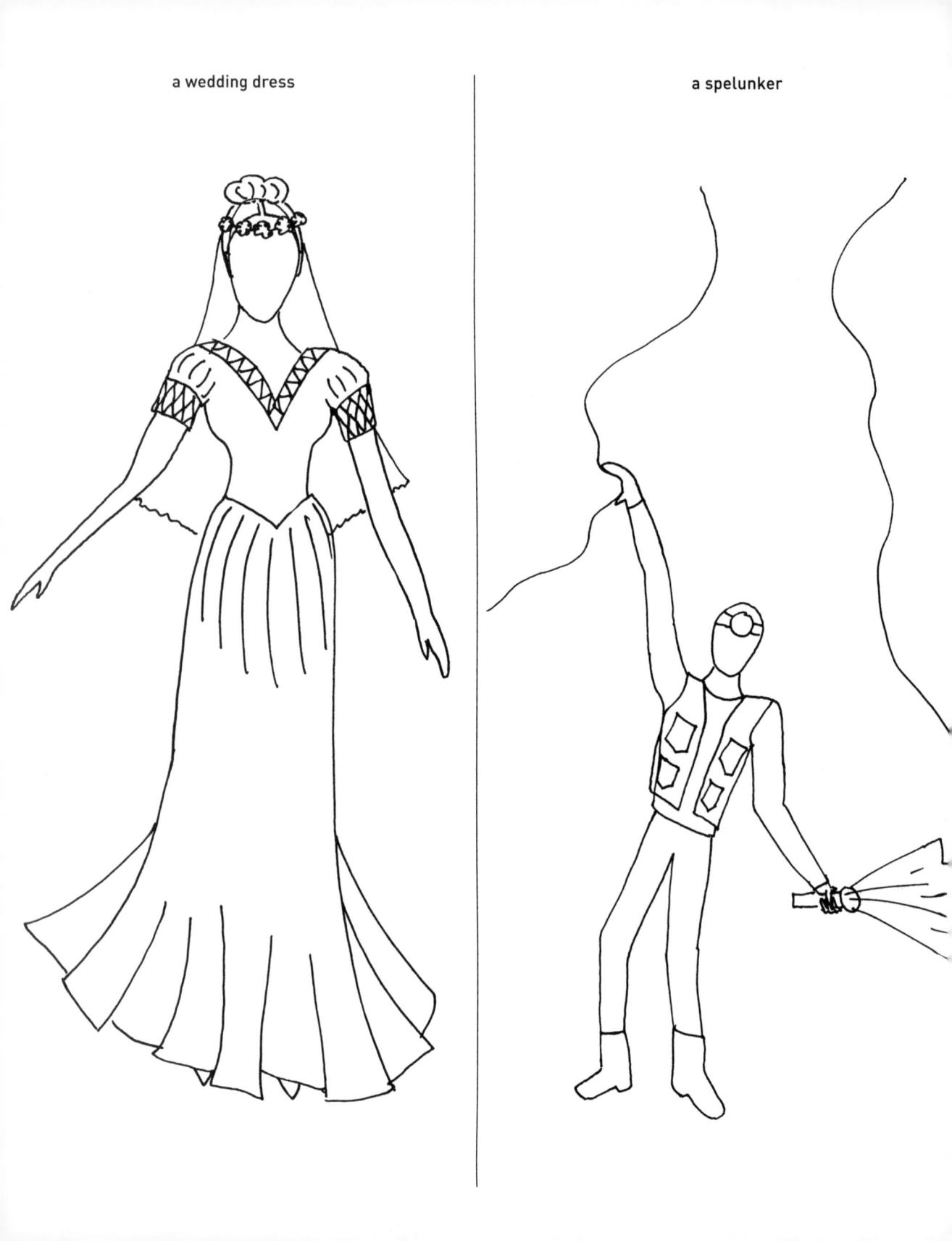

a calculator

an oven

a train

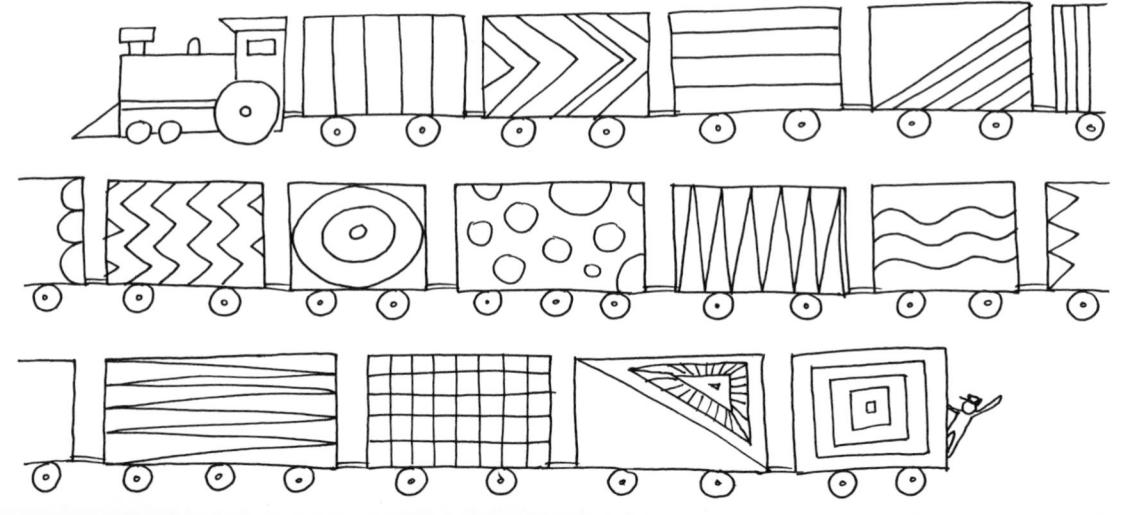
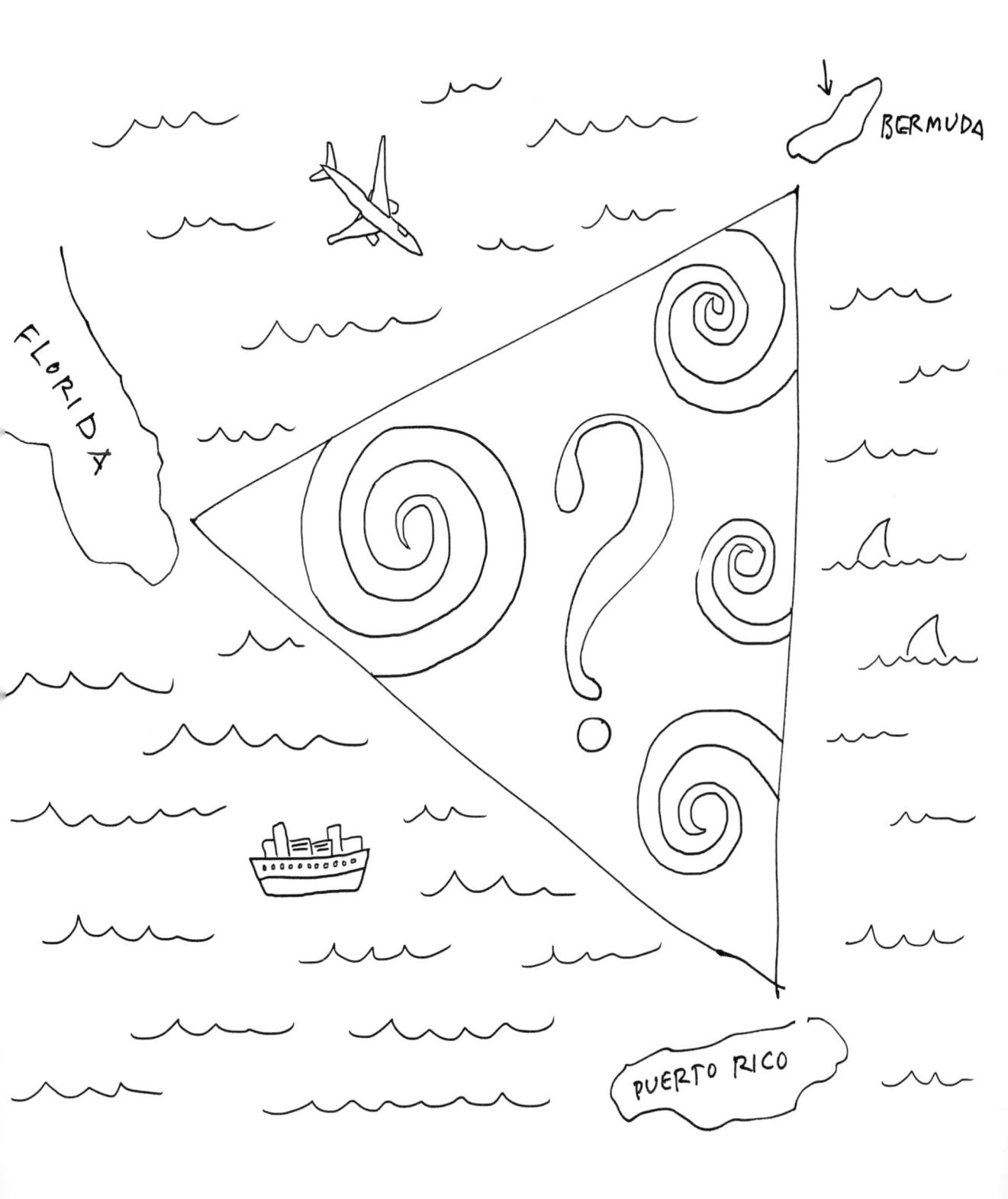

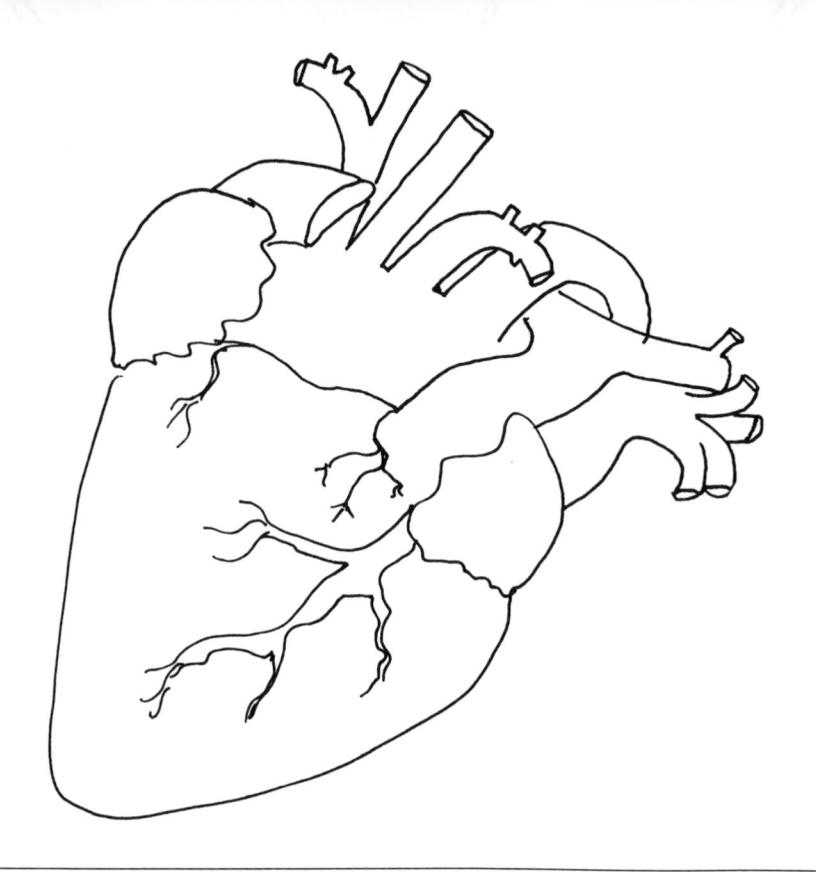

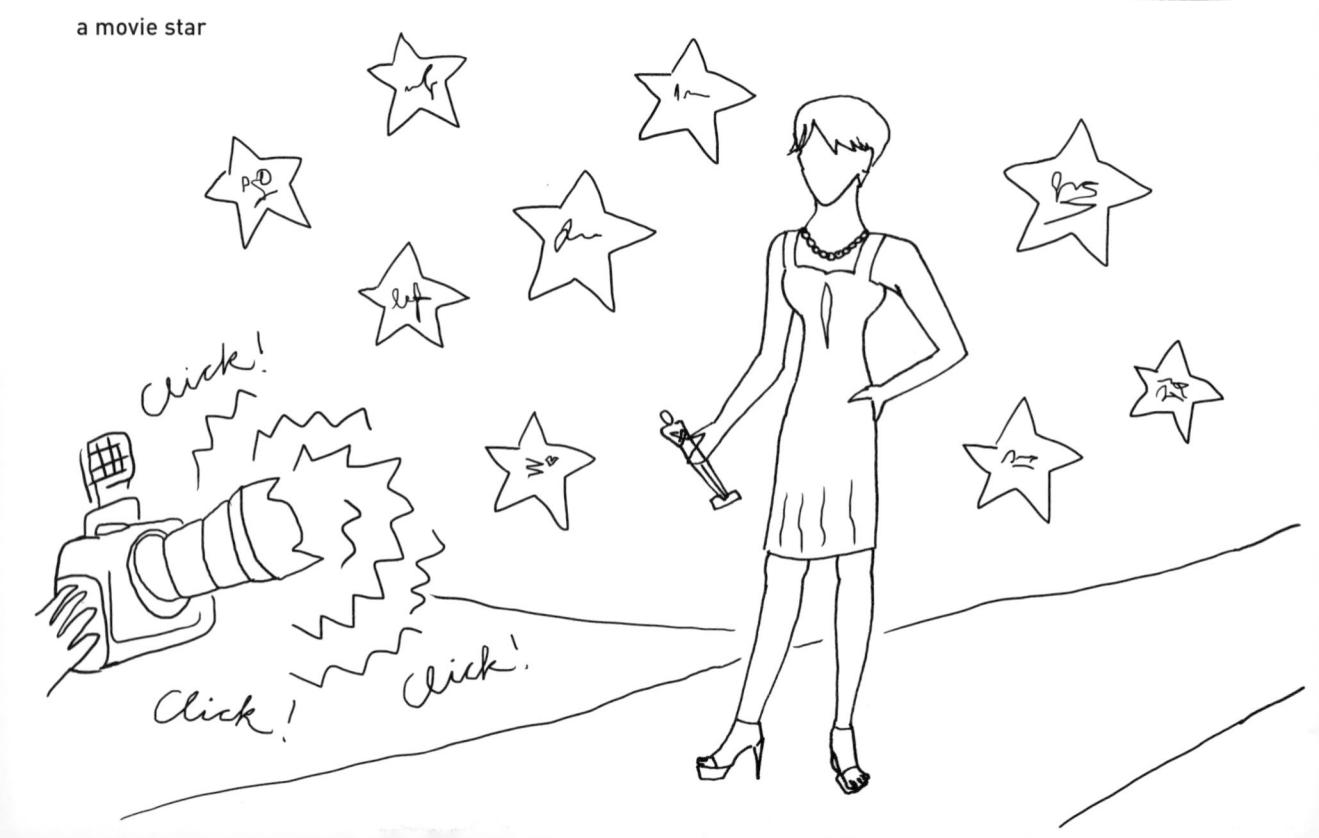

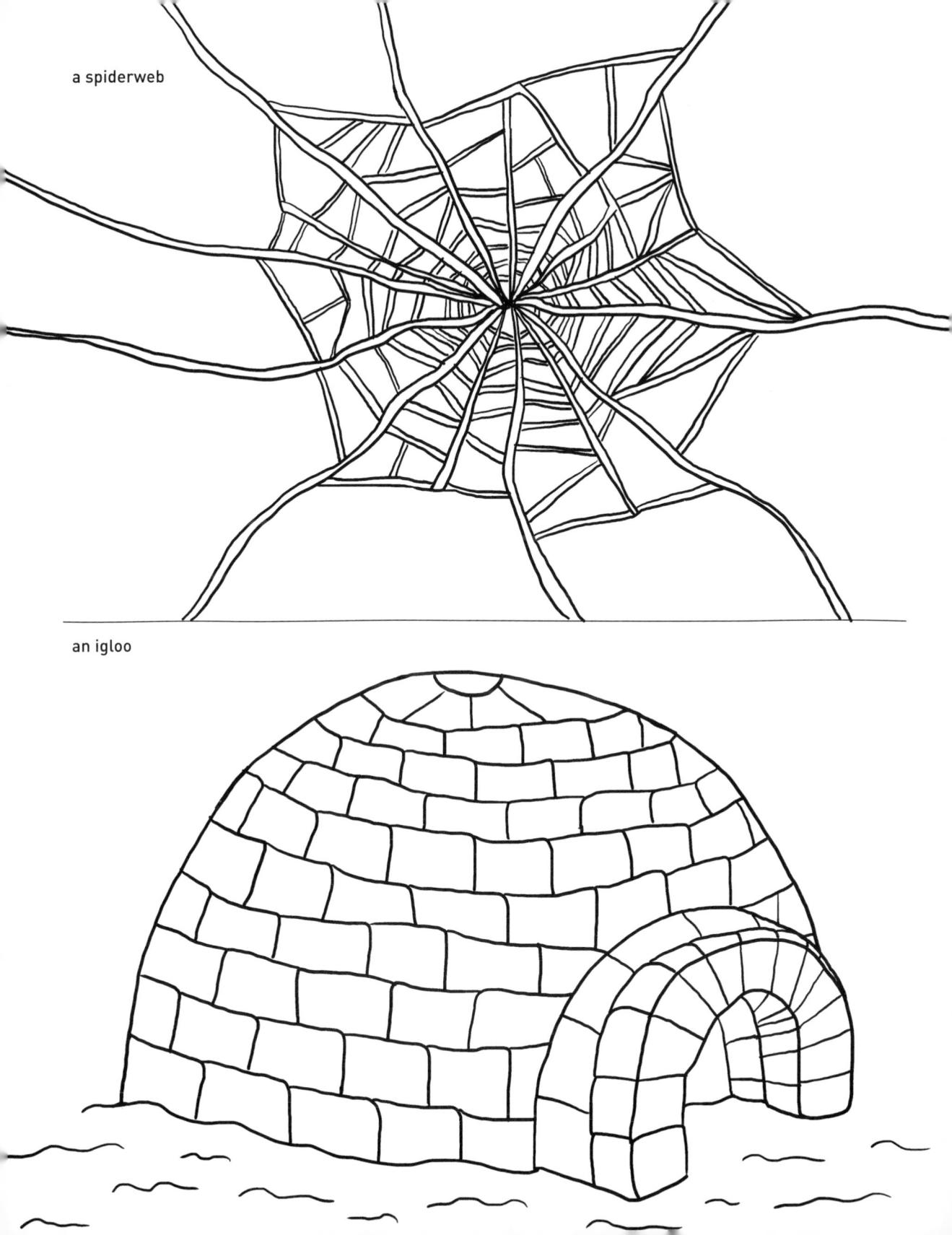

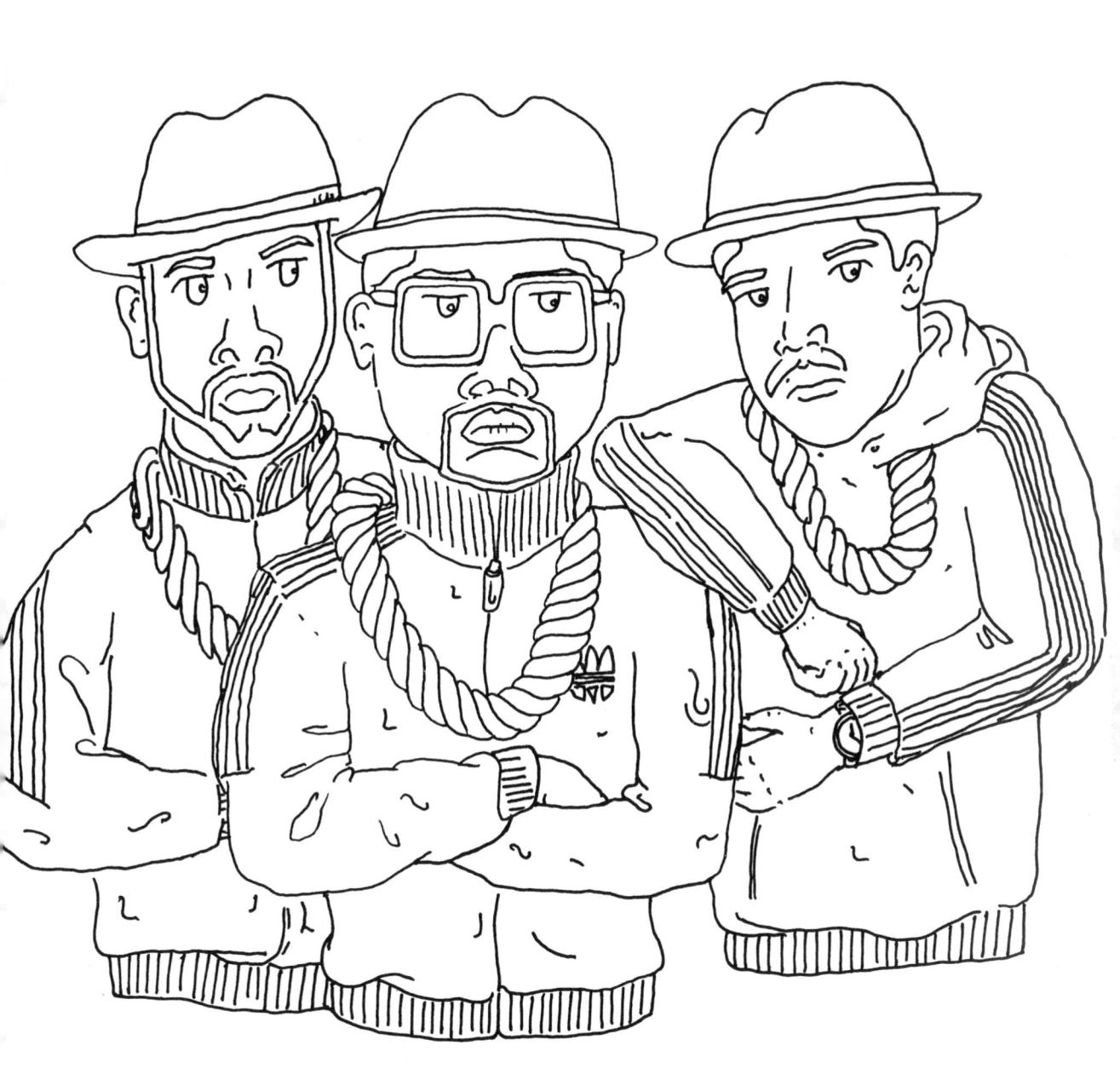

a tuxedo

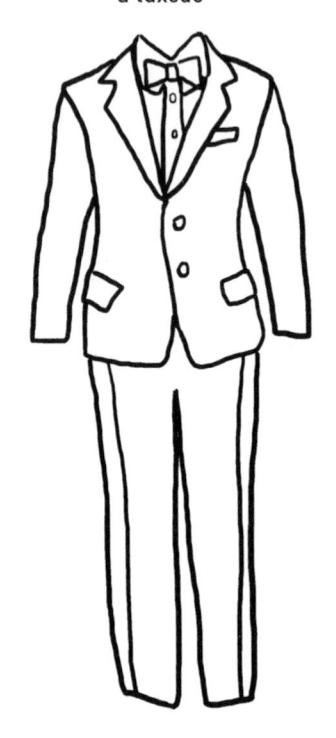

a mayonnaise jar

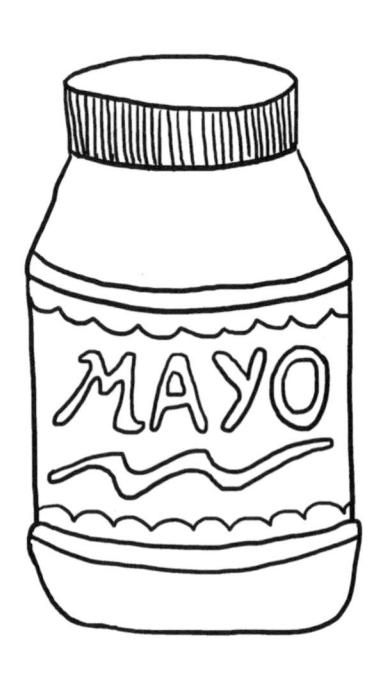

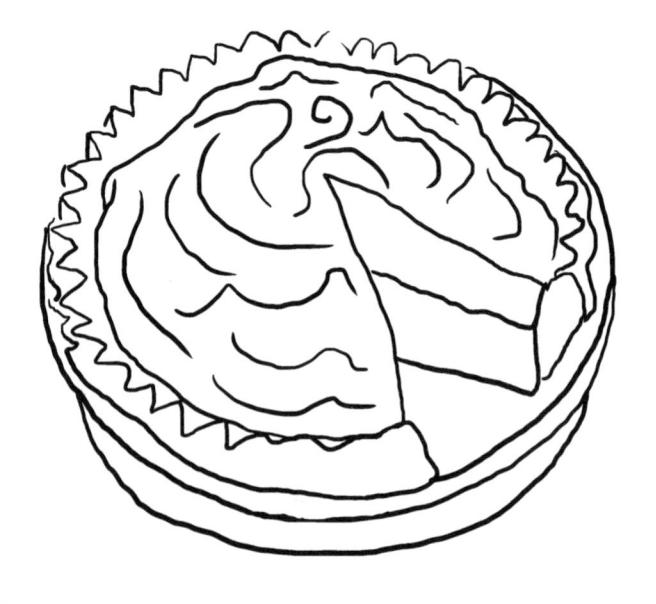

a lemon meringue pie

a sea urchin

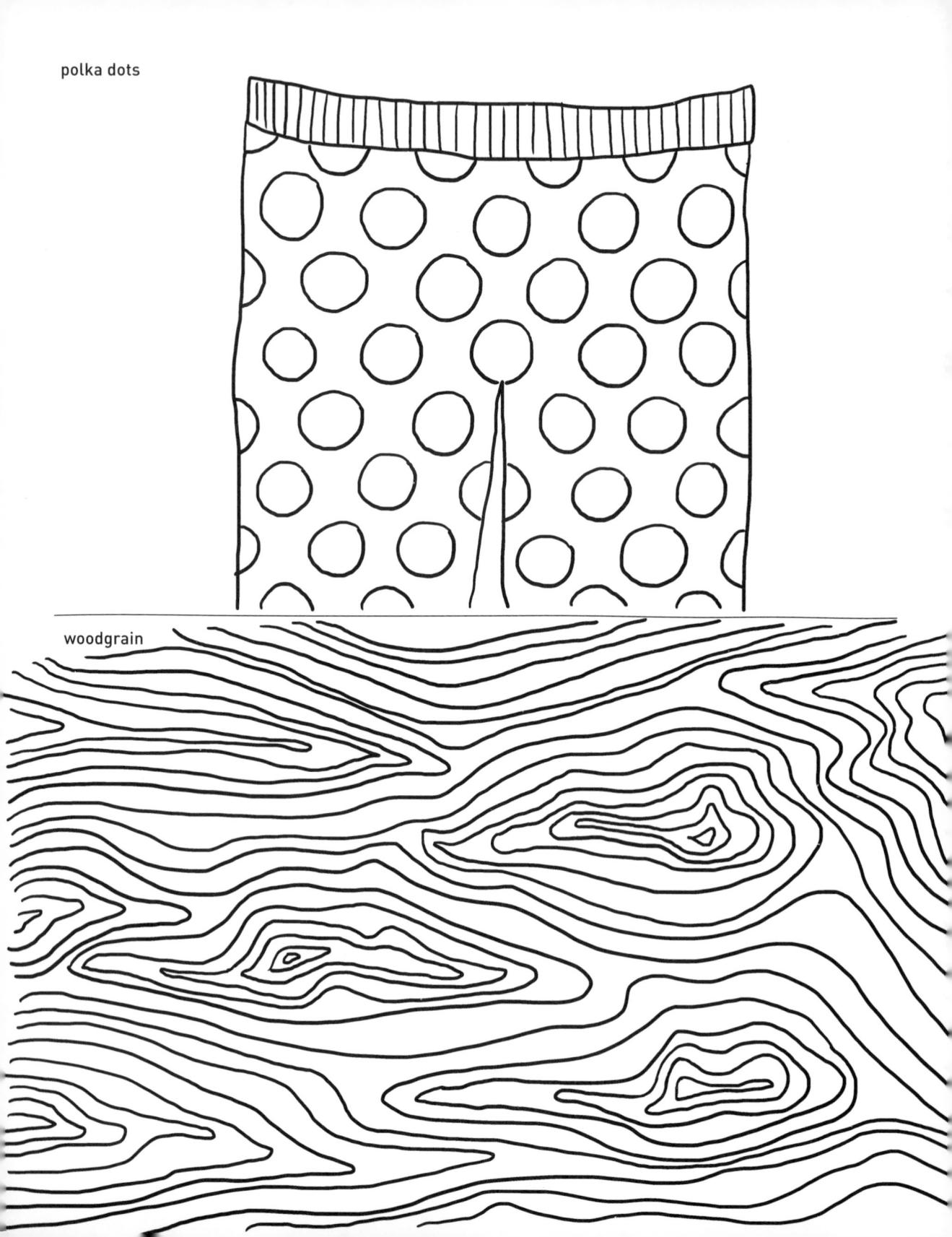

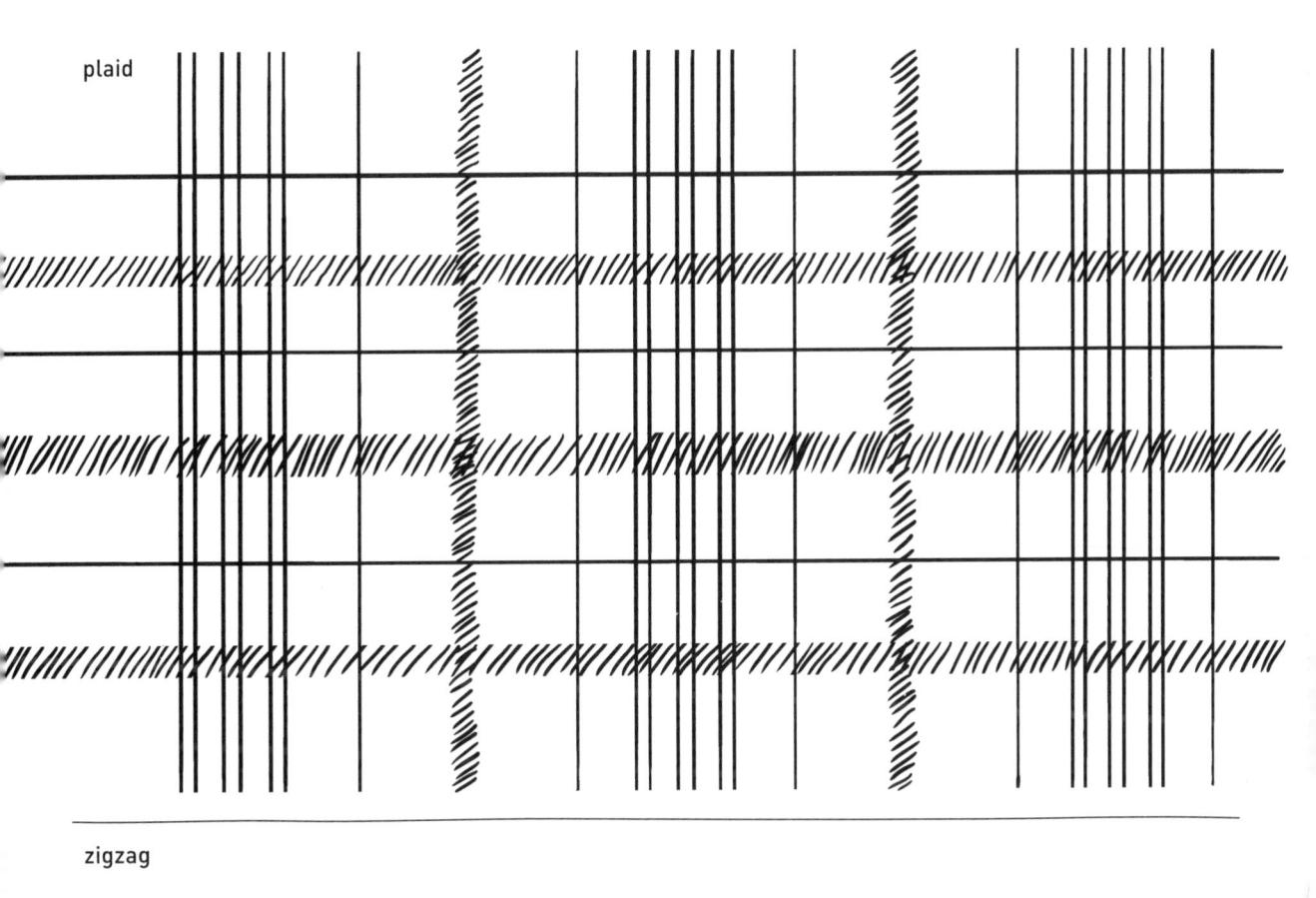

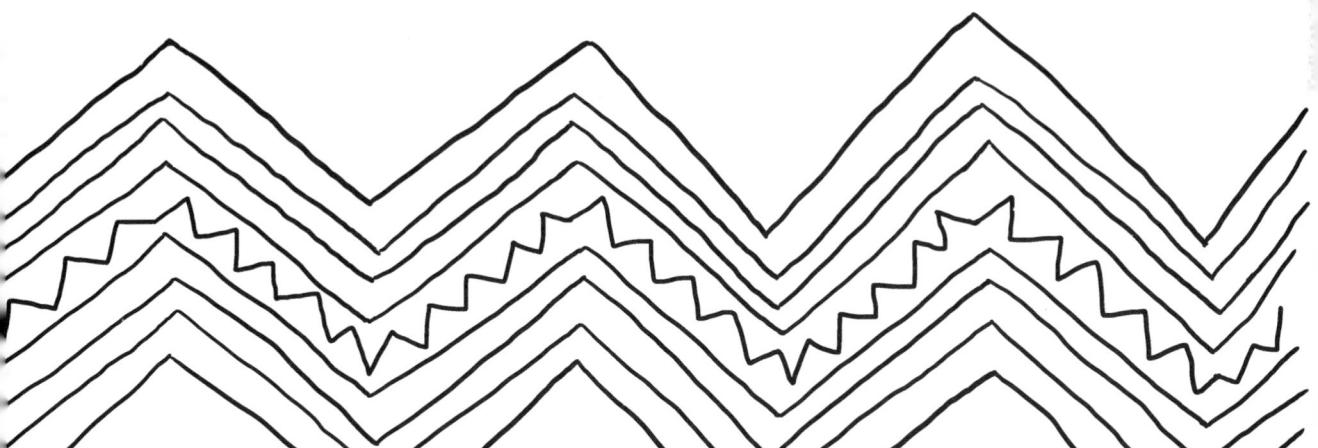

a plastic bag

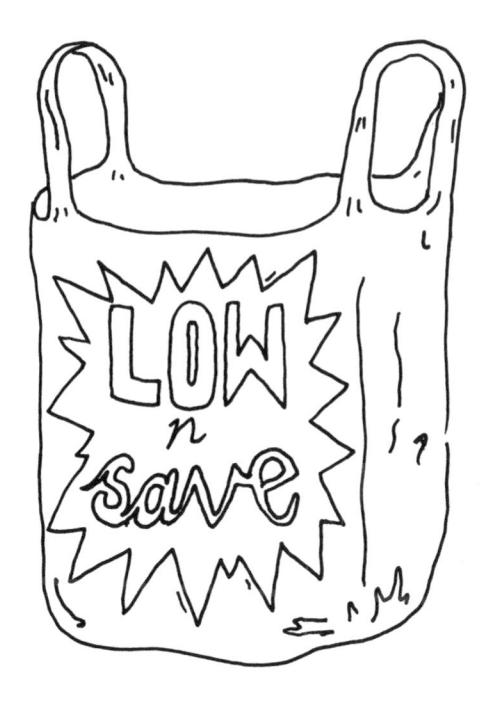

a muffin tin

a sweater

a tuba